Tales of ADORNMENT

Techniques for Creating Romantic Resin Jewelry

By Kristen Robinson

NORTH
LIGHT
BOOKS

Cincinnati, Ohio
www.createmixedmedia.com

 www.fwmedia.com

15 14 13 12 11 5 4 3 2 1

DISTRIBUTED IN CANADA BY FRASER DIRECT
100 Armstrong Avenue
Georgetown, ON, Canada L7G 5S4
Tel: (905) 877-4411

DISTRIBUTED IN THE U.K. AND EUROPE BY F&W MEDIA INTERNATIONAL
Brunel House, Newton Abbot, Devon, TQ12 4PU, England
Tel: (+44) 1626 323200,
Fax: (+44) 1626 323319
Email: enquiries@fwmedia.com

DISTRIBUTED IN AUSTRALIA BY CAPRICORN LINK
P.O. Box 704,
S. Windsor NSW, 2756 Australia
Tel: (02) 4577-3555

SRN: Z9356
ISBN 13: 978-1-4403-0866-6

Metric Conversion Chart

To convert	to	multiply by
Inches	Centimeters	2.54
Centimeters	Inches	0.4
Feet	Centimeters	30.5
Centimeters	Feet	0.03
Yards	Meters	0.9
Meters	Yards	1.1

EDITED BY Julie Hollyday
DESIGNED BY Ronson Slagle
PRODUCTION COORDINATED BY Greg Nock
PHOTOGRAPHY BY Christine Polomsky and Al Parrish
PHOTO STYLING BY Jan Nickum

DEDICATION

To Travis, my devoted and supportive husband! In all things you encourage me, support me and constantly inspire me. For everything you do and all that you are, I am forever grateful.

To my dear Conner: may all your dreams come true!

To my parents: Your constant encouragement and love is a gift beyond compare. I love you both!

ACKNOWLEDGMENTS

Without my amazing and supportive family, this book would not have been born. Your constant support, encouragement and belief in me is an amazing gift, one I cherish deeply.

To Julie, my wonderful editor, who understood my vision from the start. You have my deepest thanks.

To Tonia for believing in my dream, I am grateful.

To the amazing creative team at North Light, who brought this book to life. I am ever thankful.

ABOUT THE AUTHOR

After spending much of my life living in a suburb of a large city our wee family recently relocated to a much smaller city in southern Oregon. It is here that I have found an entire new world of inspiration and a much welcomed slower pace of life. My new studio is located in my home and it is truly my haven, a place of contentment, creating and comfort.

After working in the corporate world after college, I soon found myself seeking a return to my roots (as well as my art degree). As my background was in fashion and art, I knew the two would marry and carry my ideas to light. With a renewed courage to pursue my true dream, I set forth with paintbrush in hand. I truly feel I am on the artistic journey of my life, one I compare to dancing through the pages of a history book. With a love of all things from the past and the stories locked within them I am drawn to many different forms of art, from jewelry and textiles to painting and mixed media. It is my hope that my deep passion for writing, creating art and reading comes through in all things I create.

As a Director's Circle Artist for *Somerset Studio* Magazine, Bonne Vivante for *Somerset Life* Magazine and a designer for ICE Resin, I am truly doing what I love to do. I now offer classes online through my blog, kristenrobinson.typepad.com, as well as art retreats. As a nationally known instructor and artist, I am truly finding great joy in sharing my journey with others.

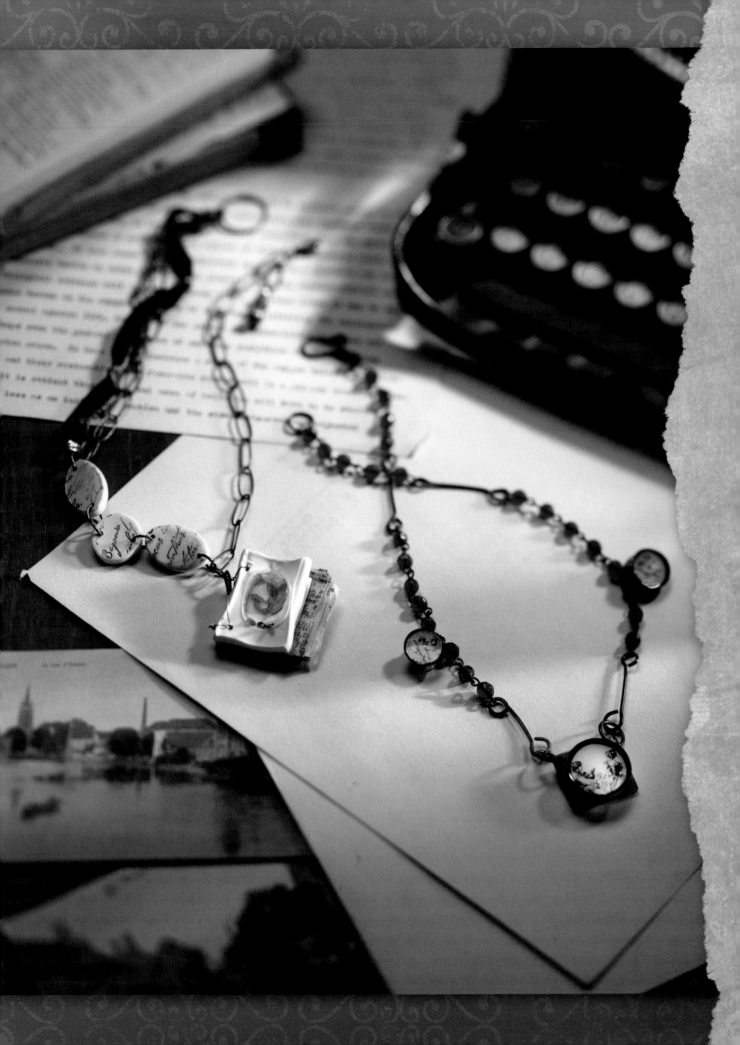

TABLE OF CONTENTS

Introduction .. 6

Techniques ... 8

✤ CHAPTER ONE ✤

Using and Making Bezels 26

Charming My Soul 28
View from Within 32
Rendezvous with History 38
Her Beauty 42
Her Name is Grace 46

Today and Tomorrow 50
Beauty's Desire 56
Faith 60
His Words 64

✤ CHAPTER TWO ✤

Using and Making Molds 70

Simplicity 72
Charlotte's Wee Secret 78
Where Art Thou 82
My Heart's Poem 86

She Speaks of Truth 90
Remembering 96
Dream From the Sea 100

✤ CHAPTER THREE ✤

Being Creative with Resin and Resin Clay 104

His Wings 106
Strength 110

The Gift 114
Fly Sweet One 118

Tools and Materials 122

Resources 126

Index .. 127

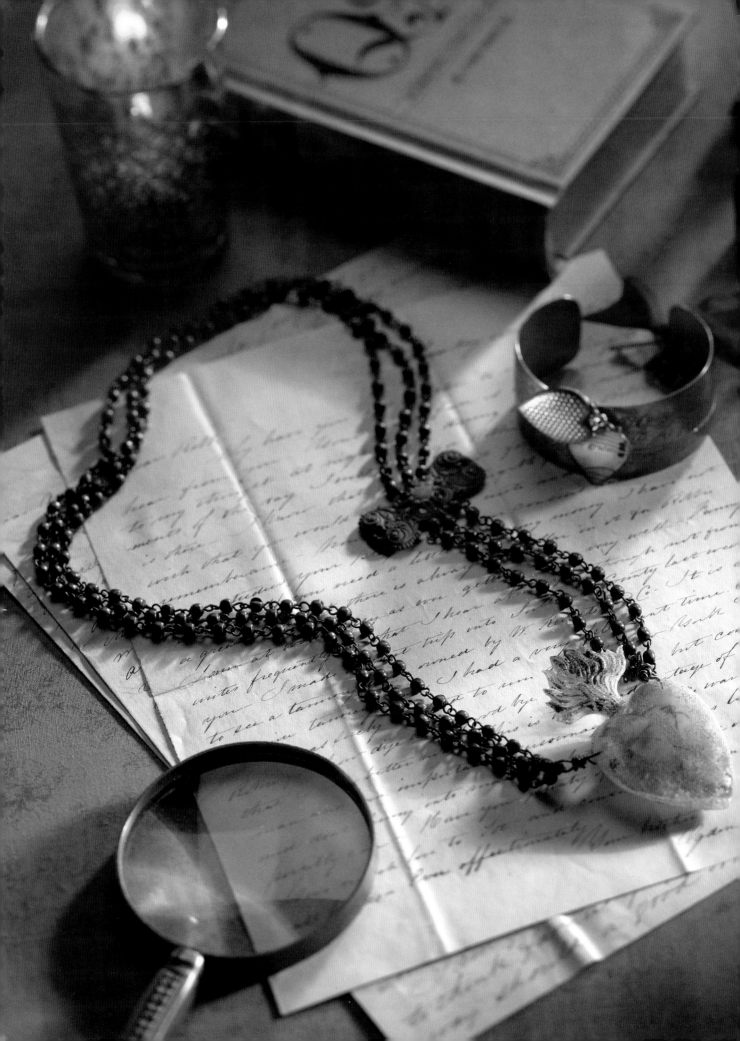

Introduction

The whole of this book is composed

of tales that build onto one another, creating fictitious histories. I believe each moment, each adornment we create and each object we treasure is our history. There is a great beauty and grace in the simpler things. New and old items alike have a story to tell, and it is our duty to pass the story on through generations.

While I have a great fondness for collected treasures as well as vintage and antique items, I often find that I am reluctant to integrate some of these into my work, as they are not replaceable. Beach glass found on a family vacation becomes an artifact, and vintage bisque birds are hard to part with. It was objects such as these that moved me to rethink the way in which I would use them.

Since I discovered resin, I have been transfixed. The chemical nature of the product leaves it a bit unpredictable, which I must admit is an attribute that draws me in. The possibilities are endless when creating with this product. Resin itself can be manipulated to replicate old glass; it can be tinted and it can be altered. When working with resin, one becomes somewhat of an alchemist and inventor wrapped into one.

In the following pages, you will find yourself transported back in time. At times, you might find yourself standing in the foyer of a famous dressmaker's shop, or perhaps in a glimmering ballroom surrounded by the haute ton of society, while at others you will stand alongside a young woman as she embarks on the adventure of a lifetime. My hope is that through this experience, you will be moved to lend your voice to the treasures nestled within your drawers and boxes. May your pearls and ribbon come to life and may your garnets and bezels don a voice.

MIXING RESIN

Use this technique anytime you want to add an extra layer of interest to your resin jewelry designs.

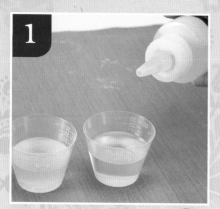
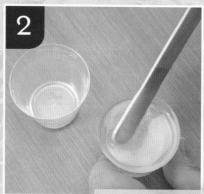

1 In two small plastic cups, measure the two-part resin according to the manufacturer's directions.

2 Combine according to the manufacturer's instructions and stir as directed on the packaging. I usually use a disposable craft stick and gently fold the resin parts together to avoid creating bubbles.

Tip

There are projects in this book that call for bubbles in the resin. To get the bubbles, quickly stir the resin together to incorporate air into it.

ADDING COLOR AND INCLUSIONS TO RESIN

Resin takes color beautifully, and this can open a world of possibilities for your jewelry creations.

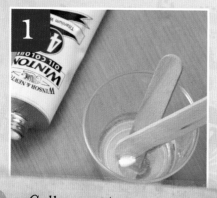
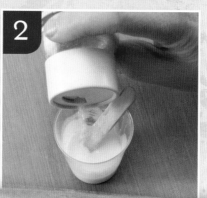

1 After the resin has been mixed, add the appropriate amount of color to the resin. Specific types of colorants and specific colors are listed in each project.

2 Gently stir in the color until it is fully incorporated into the resin. After the color is fully incorporated, you can, if desired, add glitter or mica flakes to the resin mixture. Again, stirring gently is the key to full incorporation.

Collecting Tools for Adornment

RETICULE—*A drawstring bag used especially as a carryall; from the French.*

I use the term reticule throughout the book to describe collections of tools and materials. You can store them in whatever you like—a drawstring bag, the drawer of a desk, a shoe box—whatever will make them easily available to you. Having the items grouped together will allow you to create your resin jewelry in a timely and stress-free fashion; no searching for tools; you can have them in an instant.

These reticules are referred to throughout the Materials lists for each project. Review them and gather the supplies before starting each project; additional supplies will be called for in each project's list.

Review the Tools and Materials Appendix on page 122 for more in-depth explanations of the various items.

RESIN RETICULE

- Two-part resin
- Craft sticks
- Small plastic cups
- Craft sheet
- Paper towels
- Sanding tools

PLACING IMAGERY OR OBJECTS

Use this technique anytime you want to add an extra layer of interest to your resin jewelry designs.

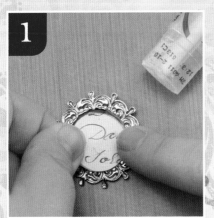

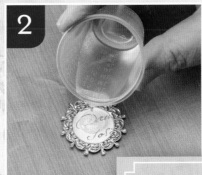

1 Print or stamp the imagery or text on the desired paper. Cut it so it will fit in the bezel of choice. Using a glue stick, secure the imagery or text into the bezel.

2 Mix and pour resin into the bezel, stopping at the top of the bezel.

Tip

If you are using vintage paper or antique documents, it is a good idea to make a photocopy rather than using the original.

BACKING OPEN BEZELS

Just a little tape lets you make resin bezels that are visible from both sides.

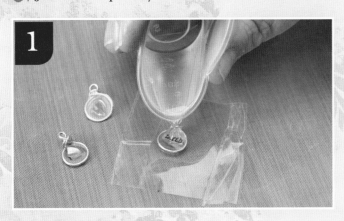

1 Place a piece of packing tape sticky side up on your work surface. Press the back of the open bezel onto the tape, ensuring that all the edges of the bezel are sealed by the tape. Pour the resin as instructed. Allow the resin to fully cure before removing the tape.

DRILLING INTO RESIN

Securing the bezel with tape will allow you more control of the drill.

1 Cut a piece of packing tape large enough to cover the bezel or resin piece and place it over the front of the bezel. Using the drill with a $\frac{1}{16}$" (1.6mm) drill bit (or the size specified in the project), drill a small hole at the top and center of the bezel. Put the drill in reverse to remove the drill bit from the resin.

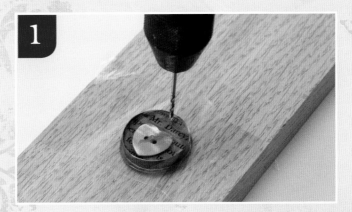

RESIN PAPER

Resin paper adds mystery to jewelry. You should wear gloves when doing this; resin can be hard to remove from skin.

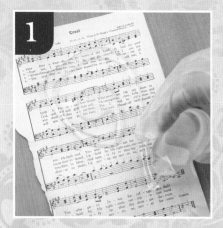

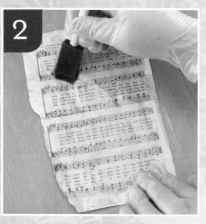

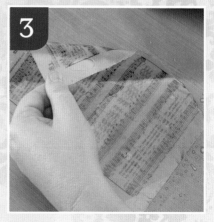

1 Lay the desired paper on a nonstick craft sheet. Mix 1 oz. (30mL) of resin and pour it over the top.

2 Using a foam brush, saturate the paper on both the front and back. Lay the paper flat on the craft sheet and allow it to dry for at least 24 hours.

3 After the resin has fully cured, peel the paper from the craft sheet. Using scissors, cut the paper to the desired shapes.

WORKING WITH TWO-PART PUTTY

Two-part putty allows you to make molds of special treasures you can't give up.

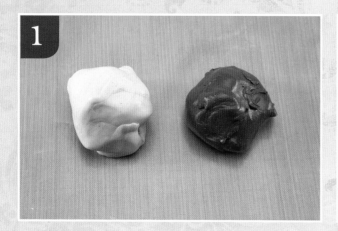

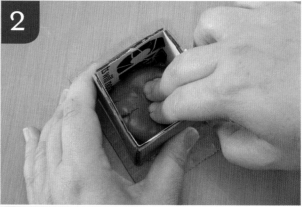

MOLDING RETICULE

- Craft sheet
- Two-part molding putty

1 Take an equal size piece of each part of the two-part putty. Working over a craft mat, use your hands to knead the two pieces together until they are completely mixed.

2 You can then use the putty for a freeform fashion, or in a mold box (shown); the instructions for the various jewelry pieces will tell you which is appropriate.

JEWELRY TECHNIQUES

MAKING JUMP RINGS BY HAND

This is a wonderful technique to know as you become more adventurous in designing your own jewelry. You can make jump rings anytime with the gauges and colors of wire that fit your piece.

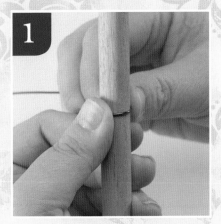

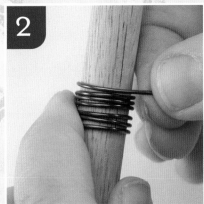

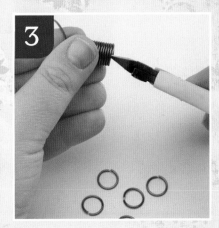

1 Cut a length of wire. Hold the wire against the dowel.

2 Wrap the wire around the dowel, making sure each wrap is snugly against the one before it.

3 Slide the coil off of the dowel. Using the wire cutters, cut the rings off in the center of each.

Tip

Using a jeweler's saw to cut the rings in step 3 will create clean ends on your jump rings.

MAKING JUMP RINGS WITH A DRILL

If you want to make a large number of jump rings in a short amount of time, a drill is a convenient tool to have.

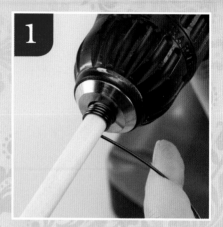
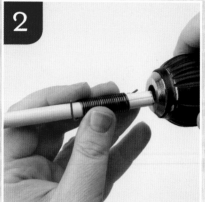
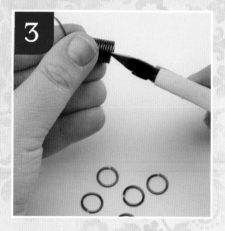

1 Insert the wire and dowel into the chuck of the drill. Engage the drill, allowing it to go slowly at first. As the drill turns, guide the wire around the dowel so each wrap fits snugly next to the previous one.

2 When you have enough coils, remove the dowel and the wire from the drill.

3 Slide the coil off of the dowel. Using the wire cutters, cut the rings off in the center of each.

OPENING AND CLOSING JUMP RINGS

Properly opening and closing jump rings ensures your jewelry will stay strongly connected. Never distort the shape of the jump ring; it should always maintain a circular shape.

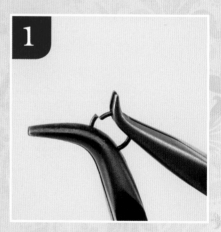
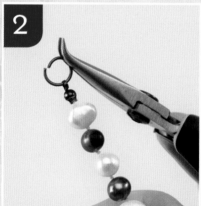
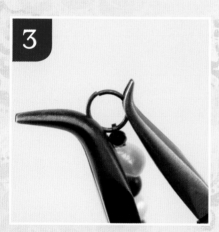

1 Using two pairs of pliers, grip the jump ring on either side of the cut ends. Using a scissor motion, open the jump ring.

2 Slide on any desired objects.

3 Close the jump ring by gripping it as you did in step 1 and bringing the cut ends back together.

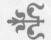

TURNING A LOOP
This technique allows you to make quick connections for links and dangles.

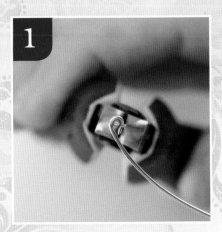

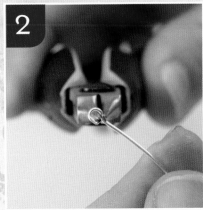

1 Using round-nose pliers, turn the end of the wire to form a loop.

2 Straighten the loop on the wire by placing the round-nose pliers at the bottom back of the loop and bending the loop up slightly.

CREATING AN S-LINK
S-links are wonderful decorative connection pieces when a simple jump ring just won't do.

HAMMERING RETICULE

- Chasing hammer
- Metal bench block
- Hammer

1 Cut a 1¼" (3cm) piece of 20-gauge wire (or the wire length and size specified in the project instructions) and turn a loop on one end.

2 Curve the opposite end in the same manner, creating a figure eight.

3 Using a bench block and hammer, hammer the link to flatten it.

13

MAKING A SIMPLE HOOK CLASP

A simple hook clasp is often all you need to enable you to wear your jewelry.

1 Cut a 1" (2.5cm) piece of wire. At one end of the wire, use the round-nose pliers to turn a loop. Wrap the wire tail around the ½" (1.5cm) dowel.

2 Using the round-nose pliers, wrap a loop at the wire end.

CLASP RETICULE

- Wire on 16, 18 and 20-gauges
- Flush cutters
- ½" (1.5cm) dowel
- Round-nose pliers

USING CRIMP TUBES

Crimp tubes allow you to incorporate the flexibility of bead-stringing wire into your jewelry design; this is an especially useful quality for a bracelet.

1 Thread the crimp tube to the stringing wire. Thread on any components as directed in the project text. Bring the other end of the stringing wire through the tube in the same direction as the first wire. Pull the wires until a loop is created at the end of the tube. Holding the wires side by side (do not let them cross), place the crimp tube in the innermost divot of the crimping pliers.

2 Move the now-curved crimp bead to the outside divot and squeeze the pliers shut. This will cause the crimp bead to fold over on itself, securely trapping the stringing wire.

Making Rosary Chain

Using simple loops, you can make an easy basic chain using any beads you desire.

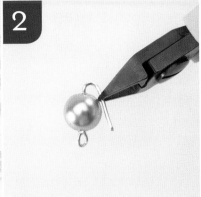

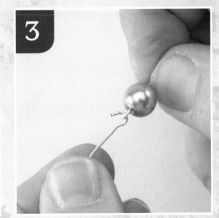

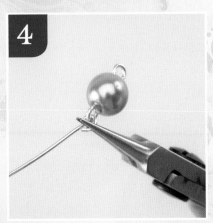

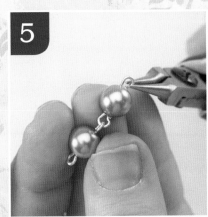

1 Do steps 1–2 of Turning a Loop (see page 13). Add a bead to the wire tail. Repeat step 1, folding the wire over the jaws of the round-nose pliers to close.

2 Trim the excess wire.

3 Begin a new segment, threading partially looped wire onto the loop of the previous link.

4 Use the round-nose pliers to fully close the new loop.

5 Repeat step 1 to complete the new segment. Repeat steps 1–4 to continue the chain.

MAKING A WRAPPED DANGLE

I prefer to wrap dangles instead of making a simple loop dangle; wrapping the dangle is more secure.

1 Thread a bead onto the head pin.

2 Using the round-nose pliers, turn the wire around the jaws to form a loop.

3 Wrap the wire tail around the wire.

4 Trim the excess wire.

Making a Wrapped Link

Sometimes a design needs a little more strength and visual heft; the wrapped link is perfect for those occasions.

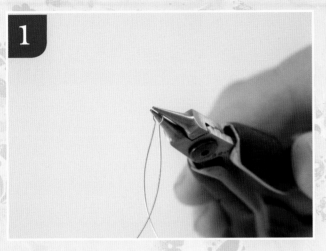

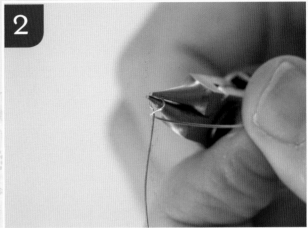

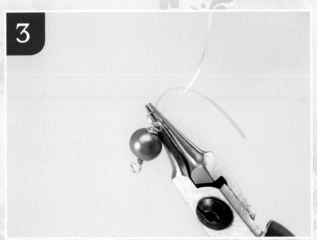

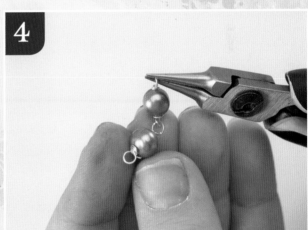

1. Using the length and type of wire specified in the project instructions, form a loop in the wire at least 1" (2.5cm) from the wire end. To do this, use round-nose pliers to turn the wire, creating a loop.

2. Bring the tail around the loop. Trim the excess wire.

3. Thread on the bead. Repeat steps 1–2 to complete the link.

4. Repeat step 1, this time threading the wire through the loop of the previous link before wrapping.

 Complete steps 2–4 to complete the link. Repeat steps 1–4 until you've reached the desired length of the chain.

STRINGING PEARLS
This age-old technique still garners beautiful results. Why change a good thing?

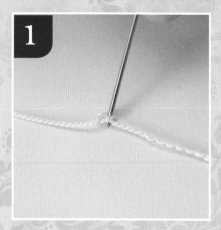

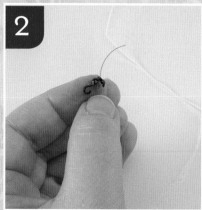

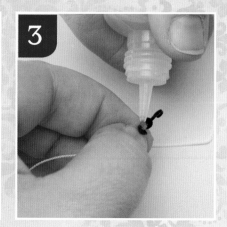

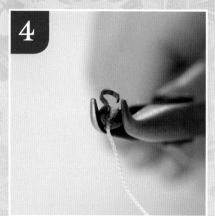

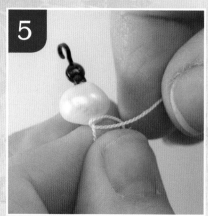

1 Holding the silk string with a T-pin, tie a double knot.

2 Slide the clamshell onto the string.

3 Trim the strings close to the knot. Use jewelry glue to secure the knot if desired.

4 Use chain-nose pliers to close the clamshell.

5 String on a pearl. Start a knot, without pulling it tight, close to the pearl.

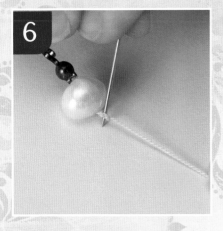

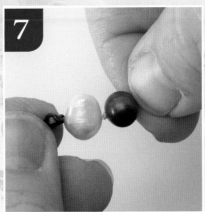

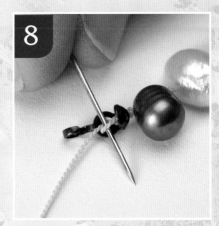

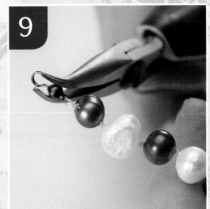

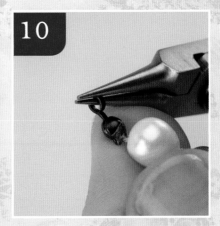

6 Using a pin, guide the knot close to the pearl. When you are next to the pearl, tighten the knot and remove the pin.

7 String on the next pearl, pushing it against the knot as you pull the string.

8 Repeat steps 5–7 until you have the desired number of pearls.

 After stringing on the last pearl and tying the knot, string on a clamshell. Use the pin to tie a knot inside the clamshell.

9 Add a drop of glue. Trim the thread close to the knot. Close the clamshell with the pliers.

10 Use a pair of round-nose pliers to close the ends of the clamshells.

Tip

If you find that your clamshells are very secure, you can skip using the glue.

EMBELLISHING TECHNIQUES

PATINA METAL

There are many ways to give new elements an aged look. This technique features a common method useful for all your jewelry-making endeavours.

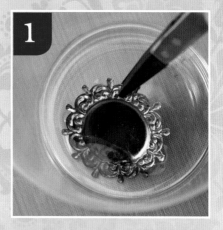

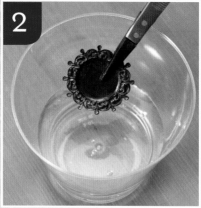

AGING RETICULE

- Vinyl gloves
- Patina of choice
- Small bowls with fitted lids
- Small bowl of water
- Plastic-tipped tweezers
- Paper towels

1 Wear gloves. Mix the patina solution according to the manufacturer's directions. Have a cup of water ready to use. Using plastic-tipped tweezers, place the metal piece into the solution.

2 Leave the metal piece in the solution until you reach the desired patina. Using the tweezers, remove the metal from the solution. Place the metal into the water to halt the chemical reaction.

3 While you are still wearing the gloves, use a paper towel to buff the metal piece.

Tip

Some metals will not age if a protective coating has been applied.

TWISTING WIRE

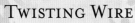

Twisted wire can add beautiful visual importance to a jewelry piece without adding more weight. You can use the twisted wire to make hooks, jump rings and S-links. Use protective eye wear when employing this technique.

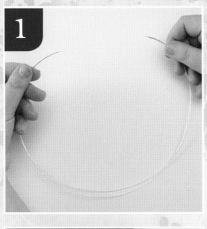

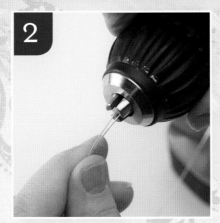

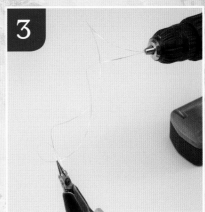

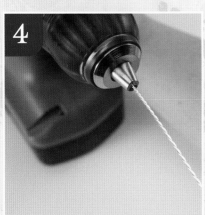

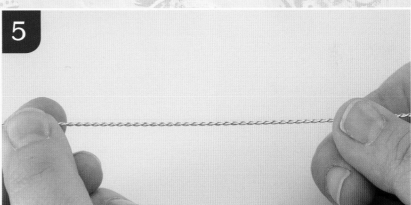

1 Take at least 1' (30cm) of wire. Fold it in half, matching the cut ends.

2 Using the drill, open the drill head. Insert the cut wire ends into the chuck of the drill and close the drill.

3 Using a pair of round-nose pliers, grasp the opposite end of the wire at the bend.

4 Hold the wire taut with the pliers. With the drill set to low, slowly begin to twist the wire by holding the wire out straight while maintaining a firm grip at the end. When the wire breaks at the chuck, it is done. Remove any remaining wire from the chuck.

5 Pull the wire to ensure it is taut and completely closed.

ETCHING METAL

Metal etching may add mystery and depth to a piece of jewelry, but the technique itself is straightforward. Always wear gloves and follow the manufacturer's safety guidelines for safe and fun etching experiences.

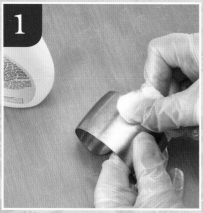

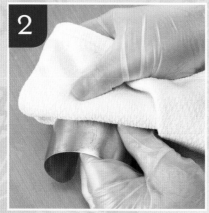

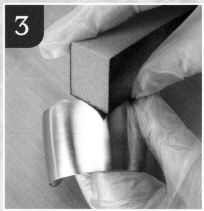

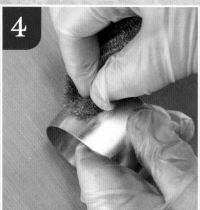

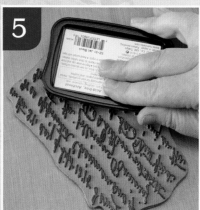

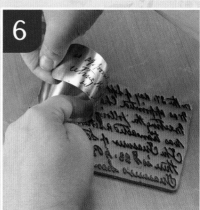

1 Wear gloves. Using a cotton ball, clean all surfaces of the metal with acetone.

2 Wipe the metal with a soft towel to dry it.

3 Using a fine-grit buffing block, rub the surface of the metal. This will create a bit of tooth for the ink to adhere to.

4 Using steel wool, rub the metal in a circular motion.

5 Using block solvent ink, saturate the stamp of choice.

6 Roll the metal cuff on the stamp. Repeat the rolling motion to cover the bracelet as desired.

ETCHING RETICULE

- Gloves
- Acetone
- Soft towel
- Fine-grit buffing block
- Steel wool
- Solvent ink
- Heat gun
- Ferric chloride
- Container with lid

- Plastic-coated tweezers
- Baking soda in plastic container with lid
- Container of water
- Toothbrush
- Steel wool
- Variety of rubber stamps
- Cotton balls
- Old cloth

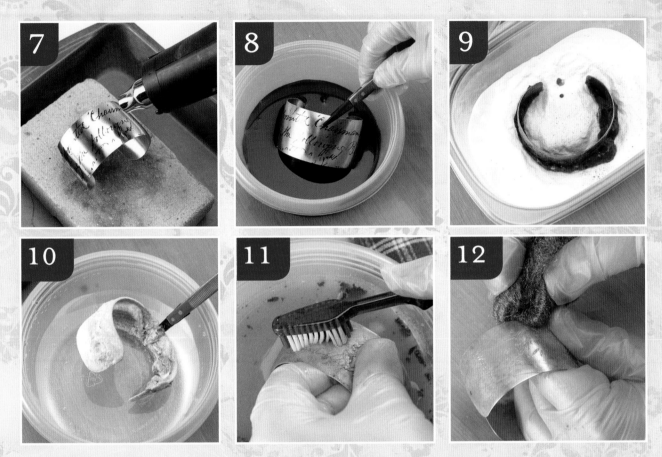

7 Place a heat block into a pan. Use the heat gun to set the ink. If you don't have a heat gun, let the ink dry completely, typically for twenty minutes.

8 With gloved hands, pour the etching solution into a plastic or glass container with a lid. Pour in enough of the solution to completely cover the metal. Using plastic-coated tweezers, place the object to be etched into the solution. Add the lid to the container. Gently agitate the solution every fifteen minutes, for one hour.

9 Use plastic-coated tweezers to remove the metal and check its progress. When you have the desired amount of etching, use the tweezers to remove the metal from the solution and place it into a plastic container filled with baking soda. Cover the metal with the baking soda to neutralize the etching solution.

10 Place the metal into a container of water to catch splashes. Have an old cloth close by the water.

11 Using a toothbrush (which must be used only for etching), scrub the surface of the metal, removing any residue.

12 When the bracelet is clean, use the old cloth to dry the metal. Using the steel wool, buff the metal. If desired, patina the metal (see Patina Metal on page 20).

Soldering with a Torch

Use a torch to make strong connections and keep items closed. I'll demonstrate the technique on a jump ring. Always solder in a well-ventilated area. I don't recommend soldering copper in an enclosed area, as it can be toxic!

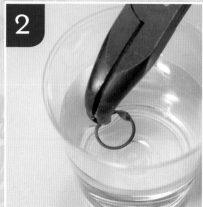
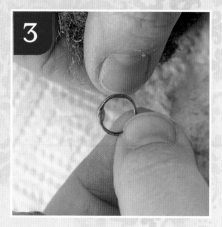

1. Remove oils from the silver with steel wool. Place the jump ring on a firing brick. Holding the solder in the one hand and the torch in the other, heat the solder. Once the flow begins place the solder over the heated ring.

2. Remove the jump ring from the brick using coated flat-nose pliers, as exposed metal will burn. Place the jump ring into the water to cool.

3. Dry the jump ring and buff with steel wool.

Making Ball Headpins

This can happen quickly with thinner gauges of wire. If you plan on making lots of headpins from many gauges of wire, consider investing in a larger torch.

Firing Reticule

- Butane torch
- Firing block
- Flat-nose pliers
- Firing block
- Pan
- Container filled with water
- Steel wool
- Solder

1. Cut the wire to the desired length. Hold the wire with flat-nose pliers over a firing block. Using a butane torch, place the end of the wire into the center of the flame. Move the torch in an up-and-down motion until a ball forms. Immediately place the wire into the cold water to halt the heating process.

2. After the metal has cooled, clean it with steel wool.

Tip

No toolbox pliers for this technique! The metal handles can heat up, meaning you could get burned. Use a pair of jewelry flat-nose pliers with the typical covered handles.

DYEING RIBBON

Ribbons, trims and fabrics can be further enhanced by dyeing. This technique is an easy way to get just the right color for your piece. Stock up on white and crème ribbons, trims and fabric for true color matches, or try to dye already-colored items to see what new shades you can make!

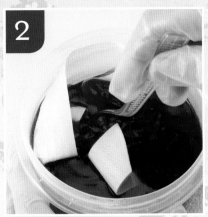

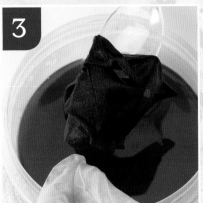

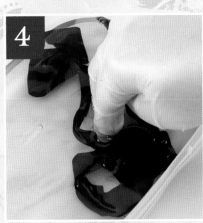

1. Heat the water. Add vinegar to the container. Add ¼ teaspoon of dye powder.

2. Wear gloves. Use a spoon to thoroughly mix the powder and the liquid. Add the ribbon, and stir.

3. Allow the ribbon to steep according to the package directions. Remove the ribbon.

4. Place the ribbon into cool water, and agitate it to remove the excess dye. Squeeze out the excess water. Lay the ribbon flat to dry.

DYEING RETICULE

- Dye
- Container
- Spoon
- Gloves

Tip

Read the package instructions carefully prior to beginning the dyeing process as directions vary by manufacturer.

Using and Making Bezels

The tales we will dance through in this section involve bits and baubles easily found at local and online stores, all waiting eagerly to tell a story. The approach is kept simple yet elegant and quite feasible. We'll also find the grace and beauty in some heavy equipment—while our saw blades and drills create a bit of noise and energy, they also help us create custom bezels for special tales.

Pearls, vintage chains, baubles, charms, antique documents and chandelier crystals intertwine, creating a glorious tale of beauty, charm and a wee bit of history. We'll embrace the idea of purchased bezels being altered or aged to appear as though they were found alongside the vintage treasures we all adore; and we'll explore the grace within a chain of pearls created with wire wrapping and rosary links, as well as a new use for a common kitchen spice.

Gather your reticules and favorite things; prepare your workspace, for we are off to create an array of masterpieces, all with their own tales to be told.

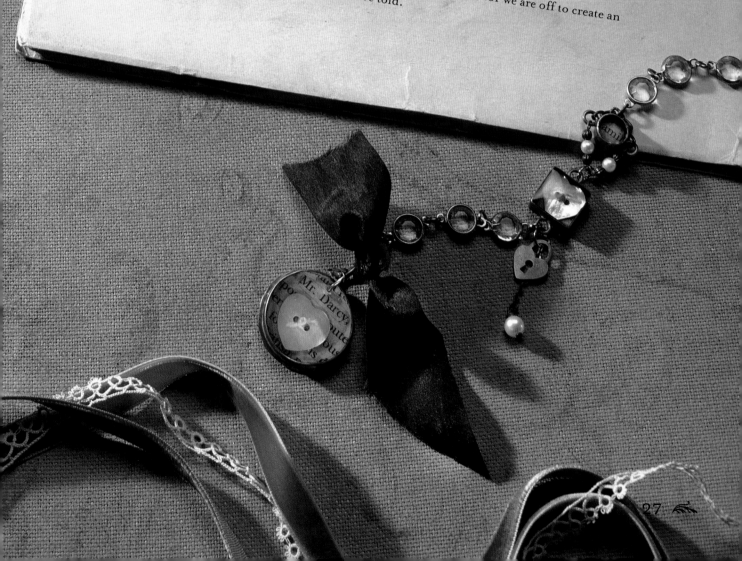

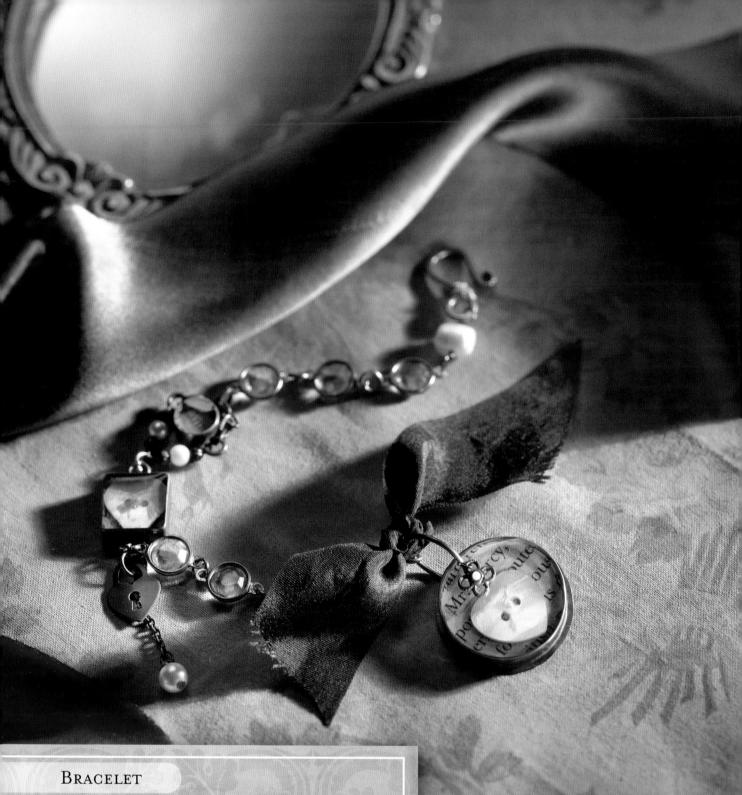

Charming my Soul

Even the unimpressionable were

left in awe of the sights at the most famous dressmaker in the city. Bolts of luscious fabric filled the rooms, while rolls of the best silk ribbon lay nestled within the safety of handcrafted drawers. Feathers and plumes, meant to tempt even the most conservative patron, danced within urns. Buttons and threads were not hidden away in the seamstress's room, but showcased as adornments meant to add a needed touch to a simple day dress or send the most lovely of evening gowns into the realm of elegance.

While the millinery and fashion necessities offered a wealth of temptation, they were enhanced by the luscious decor of the French chandeliers and the silk drapes that covered the large-paned windows, creating a sea of color where they pooled at the floor. Further beckoning patrons: A tea cart in the corner harboring the highest-quality imported tea leaves and delicate china plates hosting a bounty of sweets.

She had built her business from nothing, and now she was considered to be the best modiste in town. The years had blessed her, while at the same time she had seen and heard much that had both shocked and delighted her. Running her fingers over the bracelet she rarely removed, she felt herself falling into a cloud of reminiscence. Lifting her journal from the table, she began revisiting the many stories she had collected through her years in town. These tales were like old friends offering comfort on a cold night, friends who knew just what to say and share. Silently she fell into the trance of reading and remembering.

MATERIALS

- Resin reticule (see page 8)
- Jeweler's reticule (see page 11)
- 1" (2.5cm) round bronze bezel with clasp
- ⅜" (10mm) round bronze bezel
- ½" (1.5cm) square bronze bezel
- One 10mm heart-shaped mother-of-pearl button
- One 7mm heart-shaped mother-of-pearl button
- Four 3mm bronze beads
- Two 4mm pearl
- One 5mm pearl
- One 5mm potato pearl
- 6" (15.2cm) piece of vintage glass chain
- 1" (2.5cm) piece of 2mm bronze chain
- 1" (2.5cm) piece of 1mm bronze chain
- Small brass charm
- Small bronze charm
- Two 2mm bronze jump rings
- One 1.5cm bronze jump ring
- One 22-gauge bronze headpin
- 22-gauge bronze wire
- Scraps of book pages
- ½ yard (46cm) of 1" (2.5cm)-wide silk ribbon
- Crème embroidery floss
- Drill with ⅛" (3mm) drill bit
- Packing tape
- Plastic container filled with rice

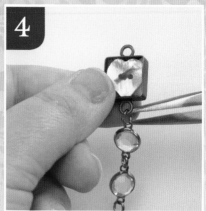

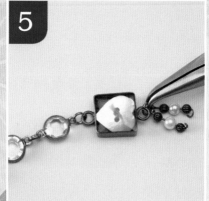

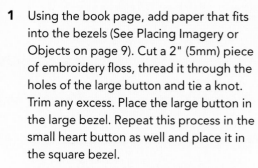

1. Using the book page, add paper that fits into the bezels (See Placing Imagery or Objects on page 9). Cut a 2" (5mm) piece of embroidery floss, thread it through the holes of the large button and tie a knot. Trim any excess. Place the large button in the large bezel. Repeat this process in the small heart button as well and place it in the square bezel.

 Place all the bezels into the plastic container of rice, adjusting the bezels so they are flat. Mix 1 oz. (30mL) of two-part resin (see Mixing Resin on page 8) and pour it into the three bezels. Let the resin cure for 24 hours.

2. Cut a piece of packing tape large enough to cover the bezel and place it over the front of the bezel. Using the drill with the ⅛" (3mm) drill bit, drill a small hole at the top and center of the bezel.

3. Place a 1.5cm bronze jump ring through the drilled hole. Before closing the jump ring, place a small bronze charm onto the jump ring and attach 2½" (6.4cm) of vintage glass chain. Close the jump ring (see Opening and Closing Jump Rings on page 12).

4. Open the end link of the glass chain and attach the square bezel to the link. Close the link. If the links do not open, use a jump ring to attach the bezel to the chain.

5. Create two separate rosary link segments using bronze bead-4mm pearl-bronze bead combination (see Making Rosary Chain on page 15). On the open end of the square bezel, use a 2mm jump ring to add the two rosary link segments.

6. Cut a 1" (2.5cm) piece of 2mm bronze chain. Use the chain-nose pliers to open the chain links on both ends of the bronze chain and attach them to the round bezel.

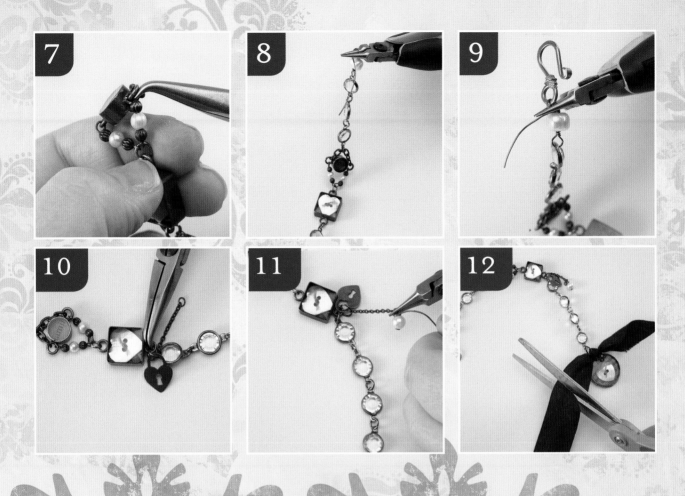

7 Using chain-nose pliers, attach the round bezel to the rosary chains.

8 Locate the center link of the chain you added in step 6; attach a 2mm jump ring to the link. Using the jump ring, attach 2" (5mm) of vintage glass chain.

 Cut a 3" (8cm) piece of 22-gauge bronze wire. Create a wrapped link using the 5mm potato pearl (see Making a Wrapped Link on page 17). Continue to step 9 before closing the link.

9 Thread the clasp hook onto the wire, and wrap the loop to close the link.

10 Open a 2mm bronze jump ring. Attach 1" (2.5cm) of 1mm bronze chain and the heart charm to the jump ring. Attach the jump ring to the bottom of the square bezel. Close the jump ring.

11 At the end of the chain, make a wrapped dangle using the 5mm potato pearl (see Making a Wrapped Dangle on page 16).

12 If the silk ribbon is not the desired color, dye it (see Dyeing Ribbon on page 25). Tie the silk ribbon to the large jump ring attached to the large round bezel. Use the scissors to trim the ribbon end diagonally, leaving about 1" (2.5cm) for the tails.

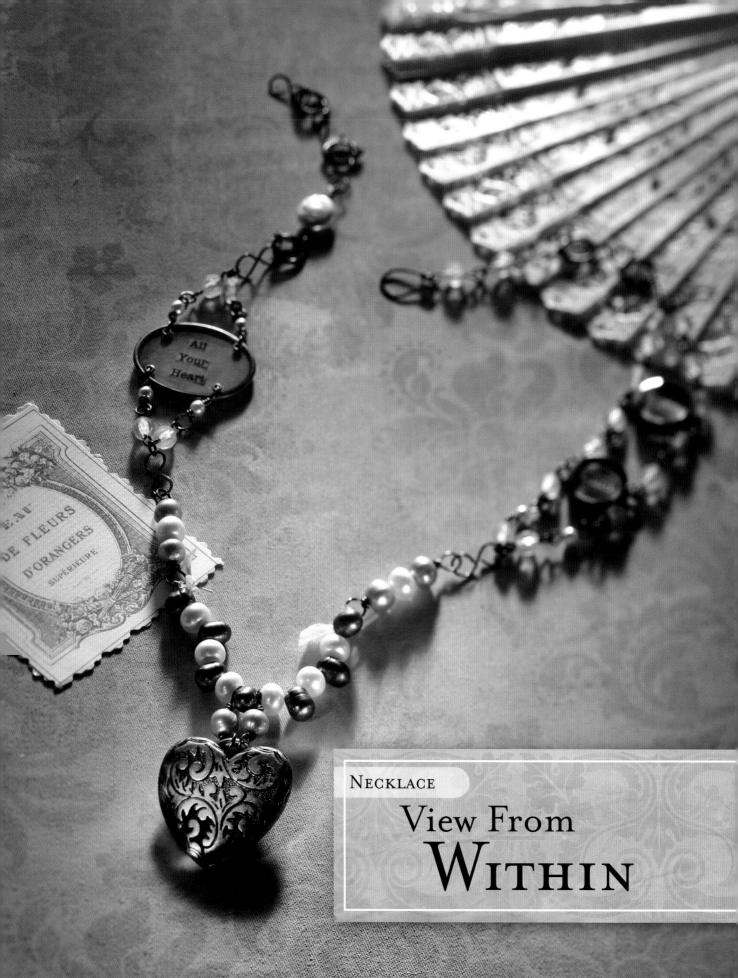

All
Your
Heart

NECKLACE

View From
WITHIN

She was full of anticipation.

Tapping her foot frantically as they waited in line, she could feel the glare at the back of her hat from her elders. Decorum was a must at all times as far as they were concerned; excitement was not an emotion meant to be seen by all. She was shocked by any person who could stand at the doors of the amazing Crystal Palace in a calm and sedate manner.

Whispers flooded town about the grandeur of what lay inside the amazing building. Those whispers had only fueled her imagination and caused many a sleepless night. Her mission was simple: she wanted to see with her own eyes the very piece of jewelry an infamous king had bestowed upon his love only to revoke it and gift it to the woman's sister. It was an amazing piece written about in history books, and only recently exhibited for the public.

The large clock that hung above the entrance chimed loudly, and at once all conversation ceased. This was it. The journey would begin any moment and her dreams would be realized.

MATERIALS

- Resin reticule (see page 8)
- Jeweler's reticule (see page 11)
- 3cm oval brass bezel
- Two 1.5cm round open-backed bronze bezels
- Eight 6mm cushion pearls
- Seven 5mm bronze pearls
- Six 5mm dusty pink pearls
- Four 2mm pearls
- One 9mm coin pearl

- Twenty 3mm vintage clear rosary links
- Two 2mm pearl rosary links (from vintage chain)
- 1" (2.5cm) filigree heart charm
- 20-gauge gunmetal wire
- 22-gauge gunmetal wire
- Six 2mm bronze jump rings
- $\frac{1}{8}$" (3mm) copper eyelets
- Scrap vintage ledger paper

- Peach seam binding
- Silk or nylon bead cord
- Drill with an $\frac{1}{8}$" (3mm) drill bit
- $\frac{1}{4}$" (6mm) dowel
- Clear packing tape

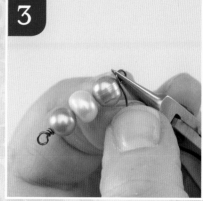

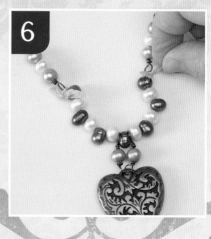

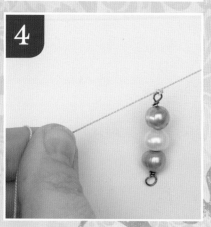

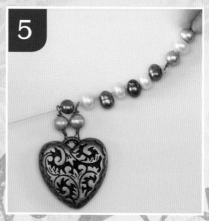

1 Lay the two round open-backed bezels on top of a piece of clear packing tape. Press down firmly on all the edges, ensuring there are no open areas.

Add the vintage ledger paper and the words "All Your Heart" to the oval brass bezel (see Placing Imagery or Objects on page 9). Mix 1 oz. (30mL) of two-part resin and pour it into the large bezel (see Mixing Resin on page 8). Fill the two open-backed bezels halfway. Let the resin cure for 24 hours.

2 Into one of the open-backed bezels place the word "See"; into the other, place the word "With." Mix ½ oz. (15mL) of two-part resin and pour it into the two open-backed bezels, filling them completely and allowing the resin to dome. Let the resin cure for 24 hours.

3 Cut a 3" (8cm) piece of 22-gauge gunmetal wire and create a long wrapped link using one 5mm dusty pink, one 6mm cushion pearl and then another 5mm dusty pink pearl (see Making a Wrapped Link on page 17).

Repeat to create a second link.

4 Thread the bead cord through the end loop of one of the pearl links and tie it in a double knot (see Stringing Pearls on page 18).

5 Using the needle attached to the cord, string on the pearls beginning with a 5mm bronze pearl and alternating with the 6mm cushion pearls. After stringing on three of each color, stop.

Create two wrapped links using the 5mm dusty pink pearls, attaching each to the heart pendant at the beginning of the wrapping process. Thread the cord string through the first wrapped link, add a 5mm bronze pearl and pass the cord through the second wrapped link.

6 Continue stringing the pearls, beginning with a cushion pearl, until the strand consists of seven bronze pearls and six cushion pearls. Tie the remaining end of the cording though the loop of the second long wrapped link.

Cut two 1" (2.5cm) pieces of peach seam binding and tie one piece over each knot using a double knot. Set aside.

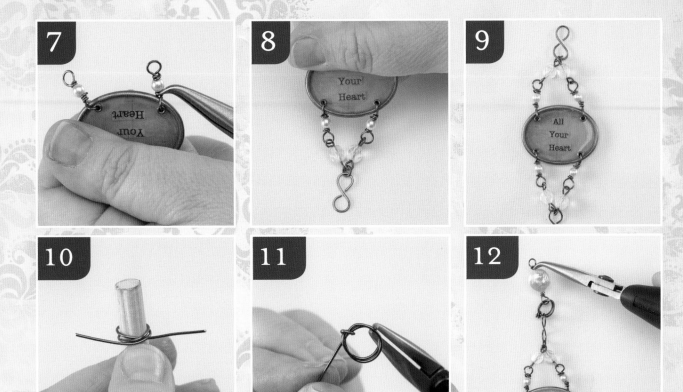

7 Using a drill fitted with a ⅛" (3mm) drill bit, drill holes, two each, through the top and bottom of the large oval bezel (see Drilling Into Resin on page 9). Place a ⅛" (3mm) copper eyelet into each hole; follow the manufacturer's instructions to secure the eyelets.

Add a wrapped link to each of the two bottom holes using the four 2mm pearls.

8 Use two links of the 3mm clear rosary links and attach one to each of the wrapped pearl links. Create an S-link from a 1¼" (3cm) piece of 20-gauge gunmetal wire (see Creating an S-Link on page 13). Use a 2mm jump ring to attach the two rosary links to one loop of the S-link.

9 Repeat steps 10–11 for the top of the bezel.

10 Cut 4" (10cm) of 20-gauge gunmetal wire. Wrap the wire around a ¼" (6mm) dowel three times.

11 Remove the wrapped wire from the dowel. Using the needle-nose pliers, wrap one end of the wire through the ring. Wrap the remaining wire from the adjoining side around. Trim any excess wire.

12 Attach the wrapped round wire to the S-link at the top portion of the bezel. Create a wrapped link using a coin pearl, threading it through the wrapped round link before finishing the wrap.

13

14

15

16

13 Repeat steps 11–12 to create two more wrapped links. Create two more S-links. To the open end of the coin pearl wrap, alternate attaching S-links and round wrapped wires. Create and attach another S-link to the links at the bottom of the bezel. Set aside this portion.

14 Create a short rosary chain using the four links of clear rosary chain and two 2mm pearls (the pattern should be clear, pearl, clear, clear, pearl, clear). Attach the ends of the short rosary chain to the open-backed bezel that says "With." To the bezel, attach two more links of clear rosary chain on each side. Attach the "See" open-backed bezel to the two links. Add three additional clear rosary links to the bezel.

15 Create two more rosary chain sections, using two clear rosary links. Attach one link segment to the top of the "With" bezel. Attach the "See" bezel to the open ends of the link segments.

16 Repeat step 15, and attach the short rosary chain to the open end of the "See" bezel. Create an S-link and attach it to the center of the bottom rosary chain.

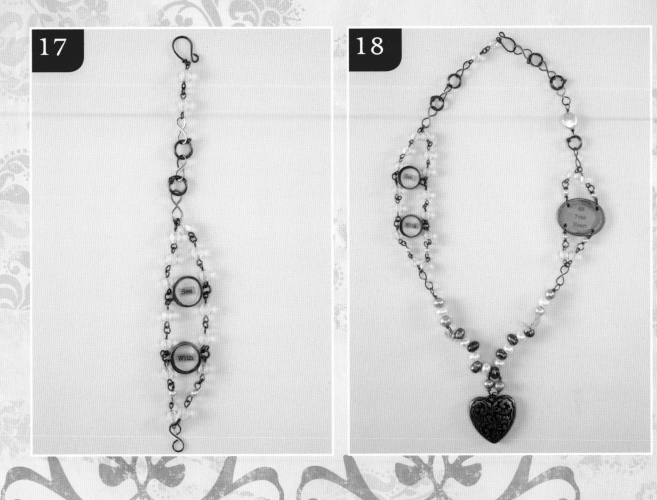

17 Repeat step 16. Attach the S-link and wrapped round wire segment in the middle of the top rosary chain (the one above the "See" bezel).

Create a hook from a 2" (5cm) piece of 20-gauge gunmetal wire and a ¾" (2cm) dowel. Attach it to the end of the S-link and wrapped round wire segment.

18 Gather all the finished sections of the necklace. Lay them out so the pearl and pendant section finished in step 6 is at the bottom, the segment featuring the large bezel is on the right, and the segment with the two smaller bezels is on the left.

Using the S-links at the bottom of the bezel segments, attach each segment to either end of the pearl and pendant section. The hook on the left will hook into the final S-link on the right.

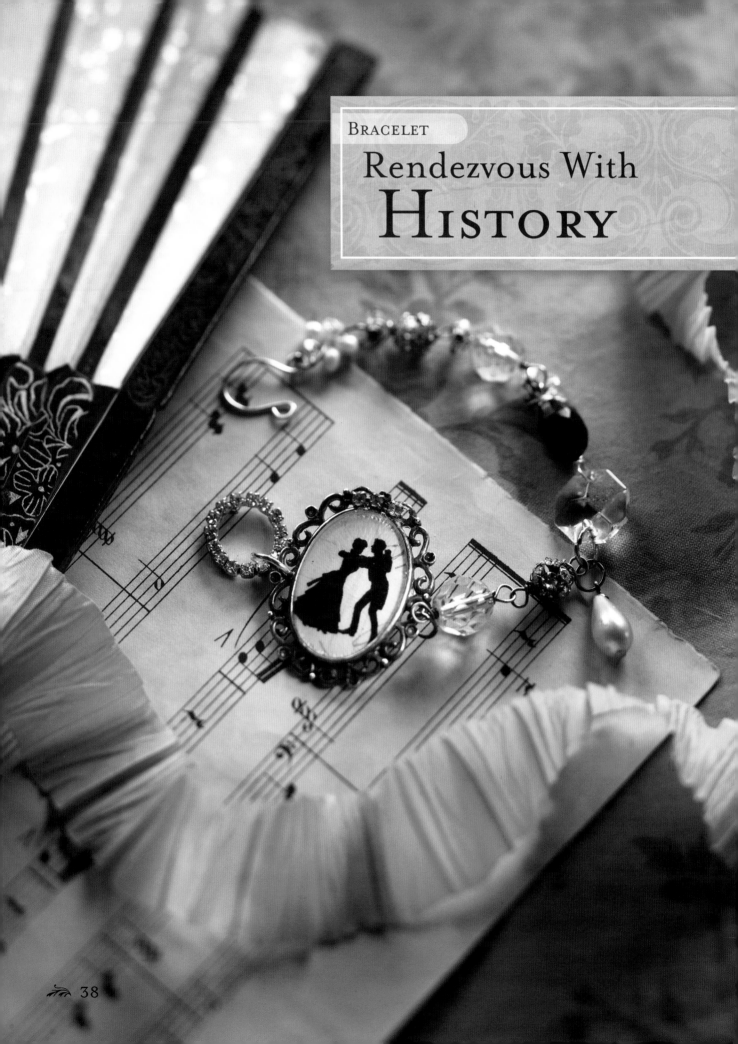

Rendezvous With HISTORY

She entered the room as the

other attendees of the ball had. Her presence was announced to all by the majordomo of the residence, his booming voice making everyone aware of just who had arrived. She glided through the ballroom with her head held high, allowing a quiet nod to those who greeted her. The soft folds of her pale gown created a swooshing sound as she walked, trumpeting her arrival to the silence laid out before her, the sound drowning in the whispers that followed her.

While others watched her, she watched the double doors that led to the terrace. He was waiting for her there, just as he had penned in his message. She continued her journey, taking in all that surrounded her, knowing this night would remain with her for eternity. With her gloved hands folded demurely at her waist, she bent her head for a final breath, and caught a glimpse of the beauty that encompassed her wrist. A cameo of a man and a woman waltzing, surrounded by pearls, crystals and treasured stones. "A promise," he called it. Moving through the double doors, she saw him. This was their chance to rendezvous with history.

MATERIALS

- Resin reticule (see page 8)
- Jeweler's reticule (see page 11)
- Aging reticule (see page 20)
- One ½" (1.5cm) filigreed bezel
- Seven 2mm round crystals
- Three 2mm center-drilled round pearls
- Two 10mm faceted blue crystals
- Two 5.5mm crystal and silver ball beads
- One 10mm chandelier crystal
- One 10mm faceted oval garnet
- One pink pear-shaped pearl
- ½" (1.5cm) 2.6mm square rhinestone trim
- ½" (1.5cm) round rhinestone link
- Five 5mm sterling silver jump rings
- One 8mm sterling silver jump ring
- 24-gauge sterling silver wire
- 20-gauge sterling silver wire
- Five 24-gauge sterling silver wire headpins
- Silhouette image
- Vintage ledger paper
- E600
- Toothpick

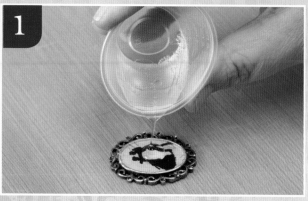

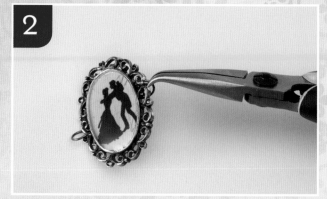

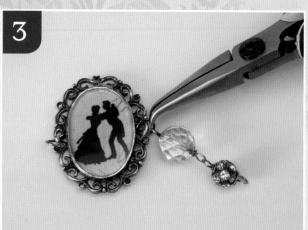

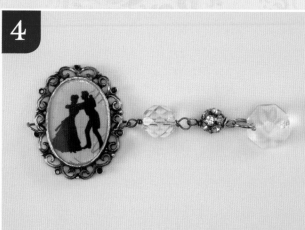

1 Patina the bezel, 15" (38cm) of 24-gauge sterling silver wire, five headpins and four 5mm jump rings with the patina solution (see Patina Metal on page 20).

On the vintage ledger paper, print a silhouette image ¾" (2cm) high. Add the image to the bezel (see Placing Imagery or Objects on page 9).

Mix ½ oz. (15mL) of two-part resin and pour it into the bezel (see Mixing Resin on page 8). Let the resin cure for 24 hours.

2 Attach one 5mm jump ring to the right side of the bezel and the 8mm to the left side (see Opening and Closing Jump Rings on page 12).

3 To the jump ring to the right of the bezel, make a wrapped wire ink segment using the aged 24-gauge sterling silver wire and one 10mm faceted blue crystal and one 5.5mm crystal ball bead (see Making a Wrapped Link on page 17).

4 Using a 5mm jump ring, add the chandelier crystal.

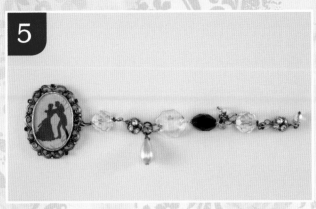

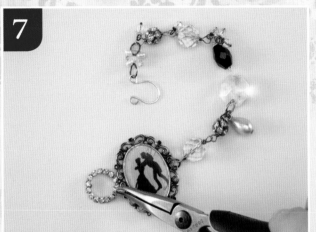

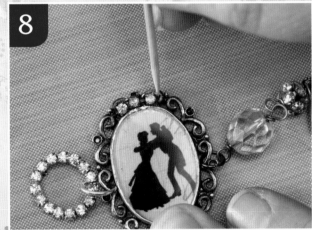

5 Continue by adding the following wrapped links to the open side of the chandelier crystal: 10mm faceted garnet; a 5.5mm faceted blue crystal and finally one 5.5mm crystal ball.

Create a wrapped dangle using an aged headpin and the pear-shaped pearl. Use a 5mm jump ring to attach it to the link between the first crystal ball link and the chandelier crystal bead.

Create three wrapped dangles from the aged headpins and the 2mm round crystals, attaching them to the following places during the wrapping process: two dangles go between the garnet and blue beads; the third is wrapped to the loop of the crystal ball at the end of the chain.

6 Create a pearl-ring link using a 1" (2.5cm) piece of 24-gauge sterling silver wire. Place the following beads on the wire: one 2mm round, one 2mm crystal, pearl, crystal, pearl. With the pearls and the crystals in the center of the wire, pull the two ends of the wire together and wrap closed.

7 Attach the pearl-ring link to the crystal ball bead using a 5mm jump ring. Create a hook using a ¾" (2cm) piece of 20-gauge sterling silver wire (see Making a Simple Hook Clasp on page 14). Attach the hook to the pearl-ring link using a 5mm jump ring.

Using the jump ring on the opposite side of the bezel, attach the round rhinestone link.

8 Cut a ½" (1.5cm) strand of rhinestone trim. Using E600, glue the square rhinestone strand onto the bezel. Use a toothpick to spread the glue, and the clean end to help place the rhinestones. Let the glue dry before wearing the bracelet.

The ladies and gentlemen

present watched with drawn breath as she entered the room. Widely spoken about was her beauty and the beauty of her voice. Sonnets had been written in her honor, speaking volumes of the magic that became tangible when she sang. Taking her place at the pianoforte, she looked about the room, awed by the support and admiration surrounding her. It was this admiration that lent her the courage she always searched for prior to performing in front of her peers.

Placing her sheet music in front of her she, hesitated as she drew her hand away from the delicate parchment, to the cameo, which rested elegantly at her bodice.

It was a cameo that had been preserved for generations with the hopes of passing talent as well as tradition to each baby girl born to the well-known family. A cameo that rested upon layers of tulle and satin ribbon and bore one simple locket to be filled with a lock of hair cut from the wearer's true love. As the recital began, her voice took flight, intertwined with the notes of the music, everyone at once mesmerized by the beauty and luster of the world around them.

MATERIALS

- Resin reticule (see page 8)
- Jeweler's reticule (see page 11)
- Aging reticule (see page 20)
- 1½" (4cm) stamped bezel
- 12mm brass locket
- 3¼" (6.5mm) length of 3mm rhinestone trim
- 17mm pin back
- Silhouette image
- Vintage ledger paper
- 10" (25cm) of 1" (2.5cm)-wide gold satin ribbon
- Beige tulle
- Thread
- Clothespin
- E600
- Fabric glue
- Needle
- Toothpick

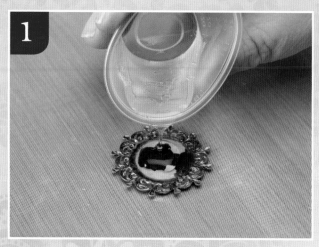

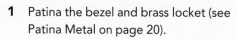

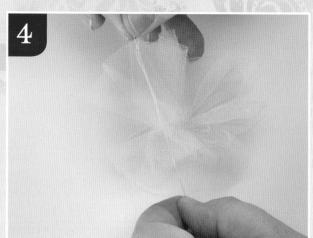

1 Patina the bezel and brass locket (see Patina Metal on page 20).

Print a silhouette image ¾" (2cm) in height onto the vintage ledger paper. Cut out and attach the image to the bezel (see Placing Imagery or Objects on page 9).

Mix ½ oz. (15mL) of two-part resin and pour it into bezel (see Mixing Resin on page 8). Let the resin cure for 24 hours.

2 Measure and cut the 3mm rhinestone trim to fit around the bezel; reserve at least one of the links for later. Glue the rhinestone trim to the perimeter of the cameo image. Use the toothpick to press the trim into the glue.

3 Cut a 4" × 20" (10cm × 51cm) strip of tulle. Fold the strip in half widthwise. Thread the needle and tie a knot at the end. With the closed edge closest to you, create a running stitch ¼" (6mm) from the bottom of the folded tulle.

4 Push the tulle down to the end of the running stitch. Tie the ends of the thread together to secure the shape. Place an extra stitch through the center and tie off to tighten it.

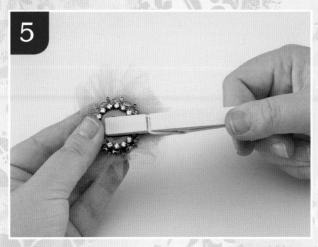

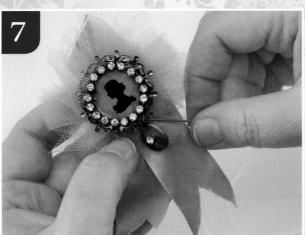

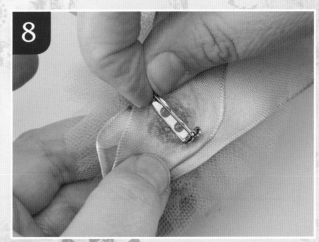

5 Add a fair amount of E600 to the back of the bezel and glue the bezel to the top of the tulle flower. Clip the clothespin on the cameo to hold everything in place while the glue dries.

6 Fold the gold satin ribbon in half lengthwise and trim the ends in a diagonal from the center fold. Unfold the ribbon and fold it in half widthwise. Arrange the ribbon so the tails separate in a V. Glue the ribbon to the back of the tulle. Use the clothespin to hold it in place while it dries.

7 Using the fabric glue, adhere the 3mm rhinestone from step 2 to the top of the locket. Let the glue dry. After the glue is completely dry, sew the locket onto the tulle flower, just under the bezel, using the needle and thread.

8 With fabric glue, glue a 17mm pin back to the ribbon. Use the clothespin to hold it in place while it dries.

grace

30

LUNETTE
D'APPROCHE

She could still hear her mother

calling to her as she ran about in the grass.

"Grace, it is time to come in for your French lesson. We do not frolic about in bare feet, my dear," her mother would say.

Of course Grace would do the right thing, returning to the spot where she left her slippers, making a show of sliding them on. She would seem to hang on her mother's every word during the lesson, while she popped off her slippers under the table.

She adored the memories of running about the wide-open space of the gardens with her siblings. Now, looking down at her cooing infant daughter, a wave of emotion hit her: One day her darling would run about in the same manner as she had. She wondered if one day she would call out when it was time for lessons to begin.

The little one reached for the dangling charms that escaped Grace's sleeve. The charms that were attached to the cuff were ones Grace's mother had passed to her, which one day Grace would pass to the next generation. Shifting to pull her daughter into her arms, she laughed. Perhaps one day she would call out to this precious darling, but for now she would sit on the blanket, enjoying the garden in an altogether different way.

MATERIALS

- Resin reticule (see page 8)
- Aging reticule (see page 20)
- Etching reticule (see page 22)
- Dyeing reticule, optional (see page 25)
- One 1" (2.5cm) vintage brass locket
- One 4mm garnet
- One 1cm Eiffel Tower charm
- One 5mm brass locket

- One 1¼" (3cm) cuff
- One 22-gauge brass headpin
- Two 5mm brass jump ring
- Sheet music
- Ledger paper
- Scarlet silk ribbon
- "Sweetness" rubber stamp (Rubber Moon)
- Script stamp

- Drill with ⅛" (3mm) drill bit
- Metal file
- E600
- Glue stick
- Pencil
- Scissors
- Small bowl of rice

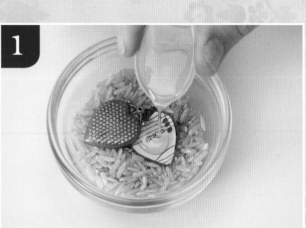

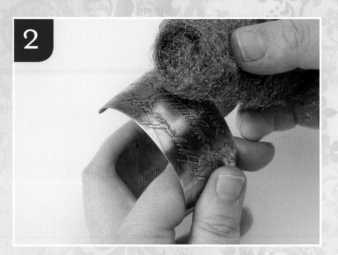

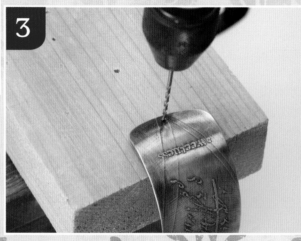

1 Line the inside of the locket with the sheet music (see Placing Imagery or Objects on page 9). Onto a scrap of ledger paper, print the word "grace." Cut out and add the word to the center of the locket.

 Place the locket into a bowl of rice, allowing the bottom to rest flat. Mix the resin and pour it into the locket, being careful not to let it touch the top of the locket (see Mixing Resin on page 8). Let the resin cure for 24 hours.

2 Etch the outside of the cuff using the desired rubber stamp (see Etching Metal on page 22). When the etching process is finished, patina the cuff (see Patina Metal on page 20). Completely clean the inside of the cuff to prevent the patina from rubbing off on skin and clothing.

3 Using a drill fitted with a 1/8" (3mm) drill bit, create a hole at the end of the cuff, centered approximately 1/8" (3mm) away from the edge.

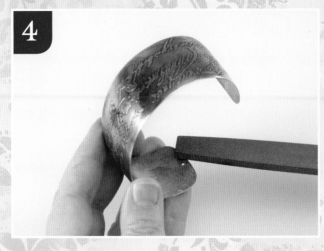

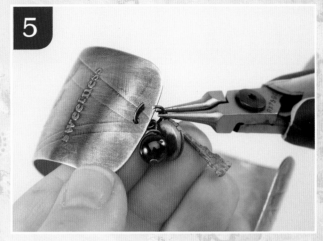

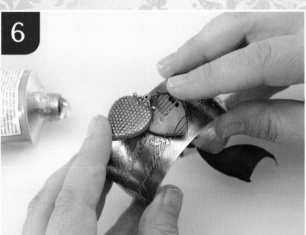

4 Using the metal file, smooth out the area where you drilled the hole. To check for smoothness as you file, carefully run your finger over the hole's opening on the inside of the cuff.

5 Create a wrapped dangle using the 4mm garnet and 22-gauge brass headpin (see Making Wrapped a Dangle on page 16).

 Thread the 5mm brass jump ring through the hole in the cuff (see Opening and Closing Jump Rings on page 12). Before closing the jump ring, thread on the garnet dangle, the Eiffel Tower charm and the 5mm brass locket.

6 Tie a 1¼" (3cm) piece of the scarlet silk ribbon through the jump ring (see Dyeing Ribbon on page 25 if the ribbon you have is not the desired color).

 Place a dollop of E600 onto the back of the heart locket and the center of the cuff. Let the glue sit for one minute before placing the locket on the cuff. Let the glue dry for twenty-four hours before wearing the cuff.

Today and
TOMORROW

Today
Tomorrow
Forever

His eyes rose to the sky,

forcing him to take note of the massive sails that reached toward the billowing clouds. One last glimpse over his shoulder allowed him a view of the land he would be leaving behind. This would be his final journey home to England; his final departure from the exotic and enchanting India. The public and his peers were told his position with the East India Trading Company was coming to an end, while the truth of the matter was deeply woven in a mass of secrets involving not only the British government but the French diplomats as well.

Making his way to the bow of the ship, he saw the petite form staring out into the span of blue. The moment he saw her he felt a flood of relief that she had made it to the ship unscathed. The beauty before him was not just a simple woman, but rather his female counterpart, the perfect decoy to enemies of the crown, as she appeared to be the innocent niece of a prominent diplomat. Together they would make this journey to their new lives.

Leaning over her shoulder, he whispered into her ear, "I see you are wearing our talisman, my love."

She smiled, raising her hand to the level of the shimmering sunlight where the bright beams caught the array of spices trapped within her bracelet. Tea leaves and spices fluttered about in the crystal-clear layers while three simple words stared at him.

"Always I will wear it. Today, tomorrow, forever."

MATERIALS

- Resin reticule (see page 8)
- Jeweler's reticule (see page 11)
- Jump ring reticule (see page 11)
- Hammering reticule (see page 13)
- Clasp reticule (see page 14)
- Aging reticule (see page 20)
- 22-gauge bronze sheet metal
- 22-gauge copper sheet metal
- 20-gauge copper wire
- 16-gauge copper wire
- Pickling spices
- Page from old French book
- Today Tomorrow Forever printed on vintage paper
- Awl
- Drill with $1/16$" (1.6mm) bit
- Jeweler's saw
- Large and small jeweler's files
- $3/16$" (4.8mm) mandrel or dowel
- Metal file
- Black permanent marker
- Cotton swab
- Foam paintbrush
- Packing tape or contact paper
- Paper towels
- Piece of wood
- Steel wool
- Soft cloth

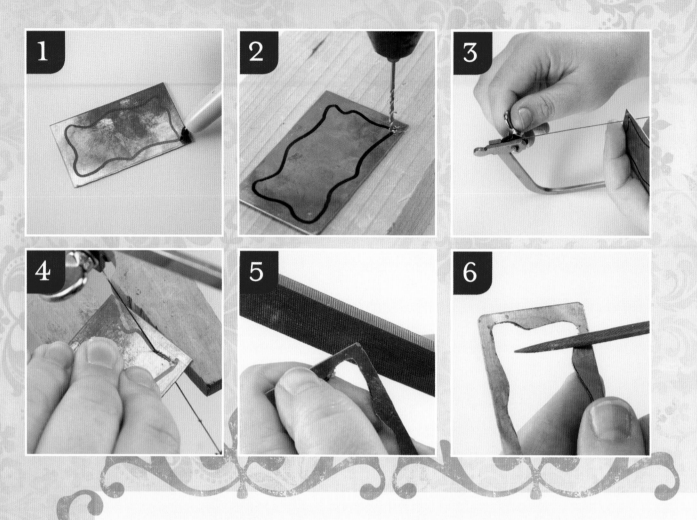

1 Using the jeweler's saw, cut a 2½" × 1" (6cm × 2.5cm) rectangle from the 22-gauge copper sheet metal. Use the black permanent marker to draw a scalloped rectangle on the inside of the shape.

2 Using the drill, create a hole in the corner of the scalloped shape on the line itself.

3 With the saw blade inserted and tightened into one end of the jeweler's saw, place the free end of the blade through the hole in the metal. Secure the free end of the blade in the saw.

4 Using the jeweler's saw, cut out the center of the rectangle following the pattern you created.

5 Using the large jeweler's file, file all the sharp edges of the copper and round the edges of the outside corners. Always move the file in one direction.

6 Using a smaller jeweler's file meant for filing curves and corners, remove any sharp edges on the inside of the rectangle.

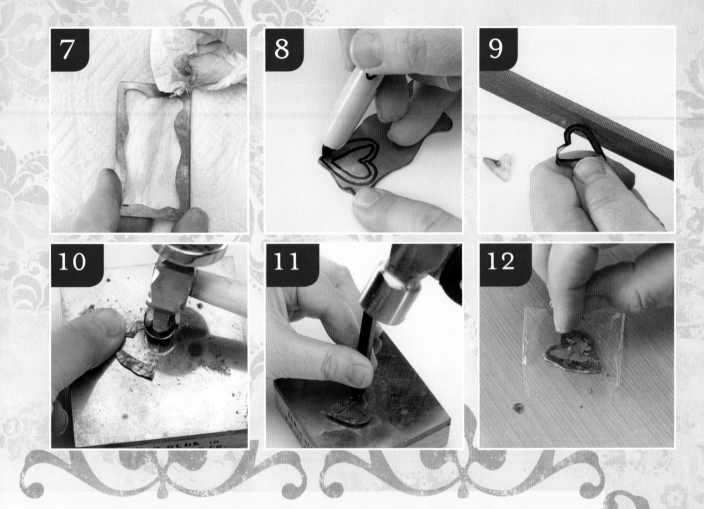

7 Prepare the patina solution from the aging reticule. Dip a cotton swab into the patina solution and rub a thin layer over the metal's surface. Let it dry. Gently buff the surface with a paper towel.

8 Using the black permanent marker, draw three hearts onto the 22-gauge bronze sheet metal. One heart should be larger, approximately 1 ¼" × 1 ¼" (3cm × 3cm), than the other two, approximately 1" × 1" (2.5cm × 2.5cm). Remove the centers with a jeweler's saw as you did in steps 2–4, keeping one of the centers to use as a charm.

9 File the metal as instructed in steps 5 and 6 to remove any sharp areas.

10 Using the ball peen end of the chasing hammer and bench block from the hammering reticule, create random marks

around the perimeter of the heart bezels. Do not mark the heart you reserved for a charm.

11 Using your stamping reticule and the letter X, place random marks on the surface of the heart charm.

12 Back the three heart bezels with packing tape or contact paper, making sure all the edges of the metal are firmly affixed to the tape. Mix resin and pour it into the heart bezels (see Mixing Resin on page 8). Sprinkle a bit of pickling spices into the resin. Let the resin cure for 24 hours.

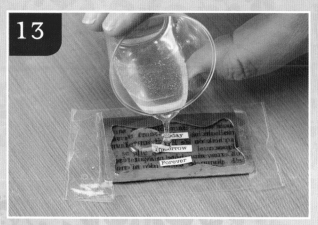

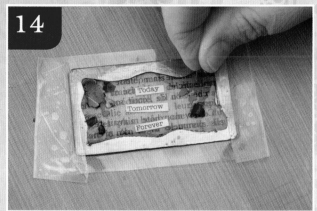

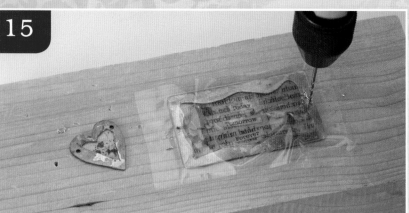

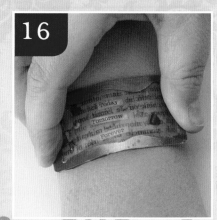

13 Create resin paper (see Making Resin Paper on page 10) using the page from the old French book. Cut a piece of resin paper slightly larger than the opening of the rectangle bezel, making sure it is not the same size as the bezel itself. Place the resin paper onto a piece of packing tape. Place the bezel on top of the paper, using a firm touch to ensure it has adhered to the packing tape. Cut out the words "Today," "Tomorrow" and "Forever" and add them to the top of the resin paper in the center. Mix the resin and pour it into the bezel. To prevent overflow, slowly pour the resin in the center and allow it to spread to the edges.

14 Sprinkle the pickling spices into the resin, letting some of the larger pieces emerge

from the piece. Let the resin cure for 24 hours.

15 Lay the heart bezels and rectangle bezel on top of a piece of wood meant for drilling. Place packing tape over the bezels. Using a drill fitted with the ⅟₁₆" (1.6mm) drill bit, create two holes (one on each side) of each of the four bezels. Drill one hole in the toward the top side of the heart charm.

16 Using a firm grip, use the small file to file the drilled holes, being gentle where the metal and resin meet.

Hold the rectangle bezel on the top of your arm. Using gentle pressure, slightly bend the bezel; being too forceful will cause the resin to crack.

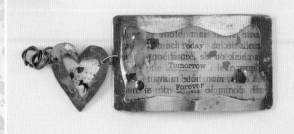

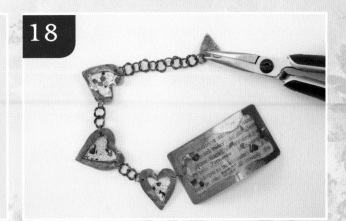

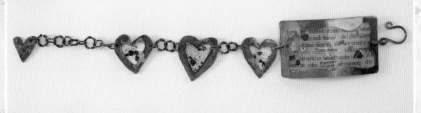

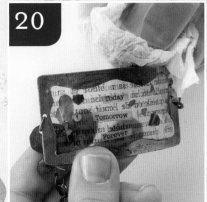

17 Make eleven ³⁄₁₆" (4.8mm) jump rings from the 20-gauge wire (see jump ring instructions on pages 11–12). Create twisted wire from the 20-gauge copper wire (see Twisting Wire on page 21) and use it to make nine ³⁄₁₆" (4.8mm) jump rings.

Place one ³⁄₁₆" (4.8mm) jump ring into the hole on the left side of the rectangle bezel (see Opening and Closing Jump Rings on page 12). Prior to closing place one of the smaller heart bezels onto the jump ring and close the ring.

Place one ³⁄₁₆" (4.8mm) jump ring through the left side of the heart bezel and close. Onto the plain jump ring, add a chain of two twisted jump rings.

18 From the two twisted jump ring chain, add the following: plain jump ring, large heart bezel, plain jump ring, two twisted jump rings, plain jump ring, last heart bezel, plain jump ring.

To this, add a chain of alternating twisted jump rings and plain jump rings until the chain segment measures 2" (5cm) and finishes with a plain jump ring. To the final jump ring, add the heart charm.

19 Make a hook clasp from a 1½" (4cm) piece of 16-gauge copper wire (see Making a Simple Hook Clasp on page 14). Place a plain ³⁄₁₆" (4.8mm) jump ring through the open side of the rectangle bezels, adding the clasp before closing the jump ring.

20 Mix up more patina solution. Using the cotton swab, dab the patina solution onto the bezels and jump rings. Let it sit until the desired darkness has been achieved. Buff the metals with steel wool and wipe with a soft cloth.

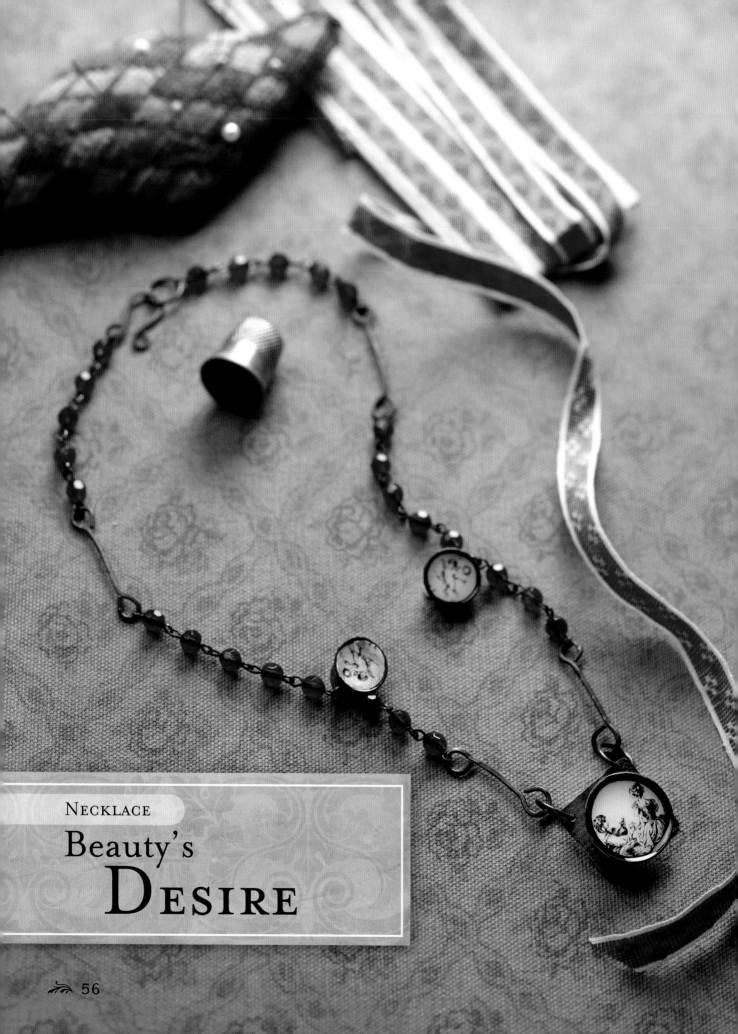

NECKLACE
Beauty's
DESIRE

She was often accused of dreaming

the day away while sitting with the other ladies. She felt the days were nothing short of empty and ridiculous while she sat and stitched. Where was the adventure in embroidery or tatting? While she admired the handiwork others produced, she was too aware that her work left something to be desired.

Outside the paned windows and charming gardens lay a world she could only dream about. Her parents, both quite old when she was born, had coddled her and, frankly, swaddled her in fear; fear of the unknown and fear of the world. She could only dream of what seemed would never be. Excusing herself from the mild conversation that filled the room, she found her chaperone and quickly escaped the house, as she was to meet a friend in the park. Anticipation consumed her as she thought of her friend who happened to be the most prominent dressmaker in the city. A woman who had offered not only friendship to a lonely girl but also relayed the most magnificent and extraordinary stories.

Walking through the park, she made her way to the dressmaker, who was sitting tranquilly on her favorite bench. Quietly, the girl joined her friend and a hushed conversation transpired between the two. The young lady begged to hear a story filled with romance and adventure. As she had before, the dressmaker obliged, relating the sweet tale of the young maiden who was swept away by a French smuggler to the dismay of her village.

The girl sat enthralled, wishing for an ounce of adventure to happen to her. As the story drew to a close, she sighed. The dressmaker took her hand and laid a simple piece of jewelry in her palm. The girl peered down at the ruby-red gems and romantic images. A piece of history, the dressmaker called it. It was at that moment she knew that adventure was in her future.

MATERIALS

- Resin reticule (see page 8)
- Jeweler's reticule (see page 11)
- Jump ring reticule (see page 11)
- Hammering reticule (see page 13)
- Clasp reticule (see page 14)
- Aging reticule (see page 20)
- Etching reticule (see page 22)

- Vintage red rosary chain
- Three 9mm jump rings
- One 5mm jump ring
- 16-gauge copper wire
- 20-gauge copper wire
- 20-gauge copper sheet metal
- Toile paper
- Dapping block
- Drill with ¼" (6cm) bit

- Metal circle punch
- Metal file
- Tin snips
- Wood block
- Cotton swab
- E600
- Masking tape

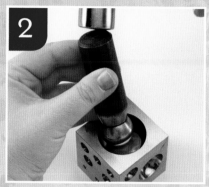
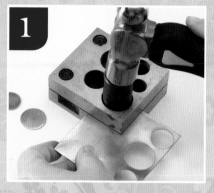
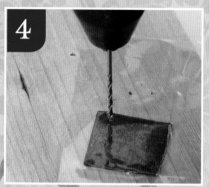
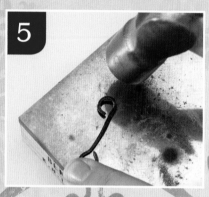
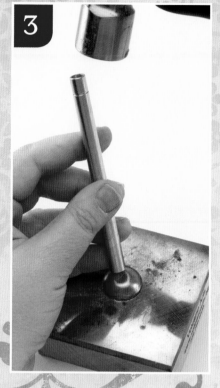

1 Using the metal circle punch, punch out one disc measuring 2.5cm, two discs measuring 2cm and two ½" (1.5cm) circles from the 20-gauge copper sheet metal.

2 Place the 2.5cm disc into the largest doming round on the dapping block. Using the dapper and hammer, move the dapper as you work in a circular motion. Hammer the disc until it forms a cup. Once the disc begins to dome, change to a smaller dapper while remaining in the same round. Once the sides begin to come up toward the top of the round, move the disc into a smaller round and repeat the process. Repeat the process with the two 2cm discs.

3 Add a flat surface to the bottom of the large bezel cup by inverting the bezel onto the bench block. Place the mandrel end in the center of the dome and tap it firmly with the hammer.

 Patina the metal (see Patina Metal on page 20).

4 Using the tin snips, cut a piece of 20-gauge copper sheet metal measuring ¾" × ¾" (2cm ×

2cm). With the metal file, round all the edges of the copper square, removing any sharp pieces. Patina the metal. Place the copper square onto the wood block. Place a piece of masking tape over it. Drill two holes along one side of the square, one hole in each corner.

5 Cut four 2" (5cm) pieces of 16-gauge copper wire. With round-nose pliers, curl one end until it meets the straight portion of the wire (this is similar to making S-links, but there is a straight section of wire in the middle of the link; see Creating an S-Link on page 13 for details). Repeat for all four. Patina the metal. With a bench block and hammer, flatten the wire links.

- -

Tip Because your metal has a patina on it, I suggest not using your best hammer. The patina can transfer from your hammer to other metals. If your best hammer is your only option, cover the hammer with a paper towel and use a rubber band to secure the paper towel.

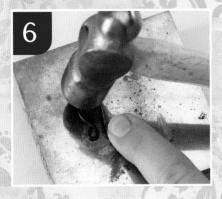

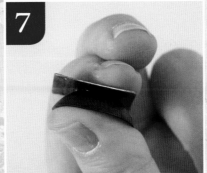

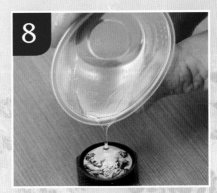

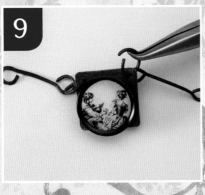

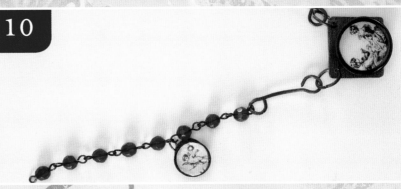

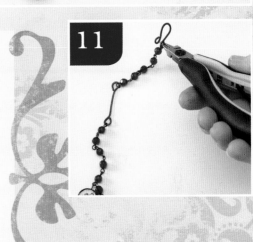

6 Create a hook clasp from a 2" (5cm) piece of 16-gauge copper wire (see Making a Simple Hook Clasp on page 14). Patina the wire. Hammer the clasp flat using a hammer and bench block.

7 Glue the etched square to the large round bezel. Glue the small round discs on the backs of the 2cm bezel cups. Allow the glue to dry.

8 Wipe any excess darkening residue from the inside of the bezel cups with a cotton swab. Cut toile paper into the shape of a circle to fit the three bezel cups (see Placing Imagery or Objects on page 9). Mix the resin (see Mixing Resin on page 8) and pour it into the bezel until it is one-quarter filled. Place the toile images into the cups and fill the remaining area with resin. Let the resin cure for 24 hours.

9 Place a 9mm jump ring through each of the holes drilled at the top of the etched backing (see Opening and Closing Jump Rings on page 12). To each jump ring, attach one long link.

10 To each of the long links, attach a 3½" (9cm) length of the vintage red rosary chain. To the first section of rosary chain at the top of the third bead, attach a small round bezel cup using a 5mm jump ring.

11 To the end of the rosary chain, attach another long link. Attach a 2" (5cm) section of rosary chain. Attach the clasp created in step 10.

Repeat the chain pattern in steps 10–11 for the right side of the necklace, attaching the 9mm jump ring for the clasp.

Tip

If you choose to solder the bezel cups to their backings instead of gluing them, choose a different metal to work with. I recommend you do not solder with copper because it releases toxic fumes.

FAITH

Sitting at the writing desk in front

of the tall arched window, she searched for the words that would complete the chapter she had been working on for far too long.

Her previous novels had been all the rage. Each novel was printed in the speediest manner possible, as the demand for her works was sweeping, to put it mildly. Proprietors of the top bookstores found themselves with empty tables and bare bookshelves in a matter hours when a new book was released. They all marveled when they were left with only a card that displayed her name and the title of the tome on the now-empty shelves.

Frustration seized her. Tapping her fountain pen on the cherrywood desk, she searched for the perfect word that would lead to the conclusion of her eleventh novel. Always one to have faith in process and self, she was surprised that self-doubt found its way to her doorstep. She stood and began the habit of pacing while pulling her bottom lip between her teeth. Pausing at the French doors that overlooked the rose garden, she closed her eyes and drew in a deep breath, taking in the sweet scent of flowers that lined the pathway below.

Her eyes flew open and she moved about the room, locating the object of her search: the necklace that her mother gifted her upon the release of her first novel. An amazing necklace that held the word "Faith" at its center and a silver disc with the word "Be" stamped into it. A reminder to be faithful to her hopes and dreams. Necklace in hand, she made her way back to the desk to complete her novel.

MATERIALS

- Resin reticule (see page 8)
- Jeweler's reticule (see page 11)
- Hammering reticule (see page 13)
- Sixteen 5.5mm iridescent grey pearls
- Eight 7mm silver potato pearls
- Three 12mm freshwater pearls
- Three 3mm coin-shaped silver pearls
- Mother-of-pearl etched bar
- ½" (1.5cm) mother-of-pearl button

- Vintage rhinestone clasp
- One 13mm silver heart charm
- One 12mm sterling silver round disc
- One 18-gauge 8mm jump ring
- One 4mm sterling silver jump ring
- One 5.5mm sterling silver jump ring
- 24-gauge sterling silver wire
- 22-gauge sterling silver Wire
- 20-gauge sterling silver wire

- Vintage paper
- Clear packing tape
- ⅛" (3mm) metal letter stamping set
- Fleur-de-lis stamp
- Drill with a 1/16" (1.6mm) drill bit
- ³/₈" (10mm) dowel
- Glue stick
- Small block of wood

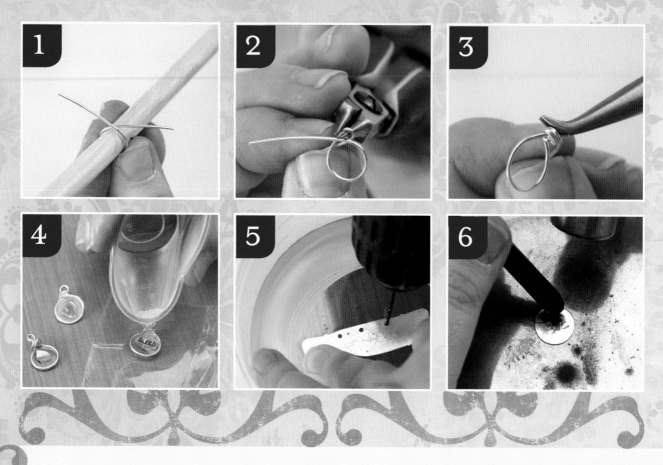

1 Cut a 2½" (6cm) piece of 20-gauge sterling silver wire. Wrap the wire around a ⅜" (10mm) dowel.

2 Using the needle-nose pliers, create a loop at one end of the wire.

3 Wrap the remaining wire tail around the loop. Trim any excess wire.

 Repeat steps 1–3 two times for a total of three wire bezels.

4 Using the wire cutters, cut the ½" (1.5cm) mother-of-pearl button into pieces creating shards not smaller than ¼" (6mm). Choose shards that will fit into the bezels created in steps 1–3. Print the word "faith" onto a small piece of vintage paper, using 6 point American Typewriter font and cut it out. Glue this word onto a shard of button.

 Back the three wire bezels with the clear packing tape (see Backing Open Bezels on page 19). To the center bezel add the button shard with text. Into the remaining bezels, place a shard of button. Mix the resin, pour it into the bezels and let the resin cure for 24 hours (see Mixing Resin on page 8).

5 Put the small block of wood into the plastic container, and fill the container with enough water approximately ½" (1.5cm) higher than the wood. Place the mother-of-pearl bar on the wood and into the water. Using the drill with the ¹⁄₁₆" (1.6mm) drill bit, position the drill bit ⅛" (3mm) from the center of the edge of the bar. Begin to drill the mother-of-pearl making sure the body of the drill is never submerged in the water. Repeat this process on either side of the first hole drilled for a total of three holes.

 On the opposite long edge, drill two holes, one at each corner, at least ⅛" (3mm) from the edges.

6 Place one 12mm sterling silver disc on the bench block. Using a jeweler's hammer and Fleur-de-lis stamp (or other desired imagery), hammer the design onto one side of the disc. On the remaining side of the 12mm silver disc, use a ⅛" (3mm) metal letter stamping set to stamp the word "BE." Patina the stamped charm (see Patina Metal on page 20). Set it aside.

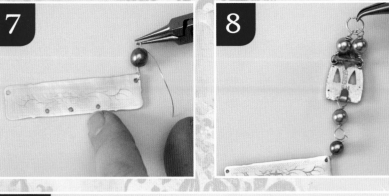

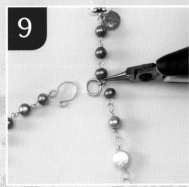

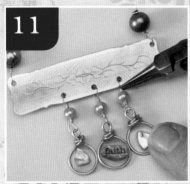

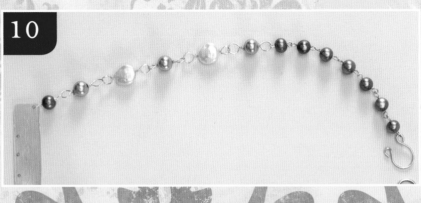

7 Make a wrapped link using a 3" (8cm) piece of 22-gauge sterling silver wire and a 5.5mm iridescent grey pearl (see Making a Wrapped Link on page 17). When you begin the wrap, thread the first loop through the right side corner hole on the mother-of-pearl bar.

8 Make another wrapped loop link with a 5.5mm iridescent grey pearl. When finishing the link, attach it to the base of the rhinestone clasp. If need be, use a pair of flat-nose pliers to crimp the vintage clasp closed.

 Create two more wrapped links using 7mm silver pearls; wrap each link to the top portion of the clasp. Attach the 4mm sterling silver jump ring through the exposed loops of the wrapped links (see Opening and Closing Jump Rings on page 12).

9 From the jump ring, continue the wrapped chain using the following beads: Grey pearl, grey, grey, sliver coin-shaped pearl, freshwater pearl, sliver, grey, grey, grey, grey. Create a wire wrapped-link chain using the sterling sliver wire and the grey pearls. Attach the stamped charm and the heart charm to the end of the short chain using the

5.5mm jump ring (see Opening and Closing Jump Rings on page 12).

 Between the first two grey pearls in the last segment, add the 8mm jump ring to one of the loops.

10 To the left side of the mother-of-pearl bar, create wrapped link chain using the following beads: Grey, silver, freshwater, silver, freshwater, silver, and seven grey pearls. Make a hook using a 1" (2.5cm) piece of 20-gauge sterling silver wire (see Making a Simple Hook Clasp on page 14). Attach the hook to the chain before wrapping the last loop.

11 Through the remaining holes in the mother of pear bar, make wrapped loops using 3" (8cm) pieces of 24-gauge sterling silver wire and the 3mm silver pearls. Before closing each link, thread on a bezel. The bezel with the word "faith" should be in the middle.

- -

Tip If your wire bends during wrapping, place it back onto the dowel to help reshape it.

NECKLACE

His Words

Standing in the center of the great

room that was once her husband's study, she found the sadness that had consumed her for weeks now was beginning to drift away. Slowly, as she seemed to do all things at her age, she made her way to his worktable. Comfort flooded her as she reminisced about his time there—long work hours and candles burning to their bases—filling her heart and soul, which had felt empty for weeks.

Leaning against the large bench, she placed her hands atop the table, feeling the marks and divots with her fingertips. A stillness entered the room and offered her a sense of calm and serenity. She could almost sense his presence by her side. She marveled at the hours he had sat at this very desk studying his botany books, going over lists and notes referencing the experiments and growth projects in which he had invested his life. How much he had given and devoted to his profession.

Pulling a heavy ledger toward her, she opened it, seeking to find comfort in his handwriting, in the lists and notes. Coming to what she thought was the center of the book, she happened upon the beginning of the conclusion. A simple ribbon with a key attached marked the page. Running her hand down his last words, she stopped, finding not notes but journaling that had been added to this book of information. His words spoke of love for her, their family, and the comfort he felt knowing his last days were spent filled with happiness. At the end of the entry a simple sentence had been penned.

"Open the drawer, my love."

Pulling the key from the book, she bent slowly to open the drawer. Among the stacks of pencils and paper lay a simple necklace with a small book attached. Pulling it into her weathered hands, she felt tears fill her eyes. A part of him would always be with her.

MATERIALS

- Resin reticule (see page 8)
- Jeweler's reticule (see page 11)
- Aging reticule (see page 20)
- Firing reticule (see page 24)
- Faux Bone
- One 3mm grey pearl
- One 3mm grey crystal
- One 5mm iridescent grey pearl
- 7½" (19cm) length of silver chain
- Ten 5mm jump rings
- Three 3mm jump rings
- One 2cm silver ring

- 24-gauge sterling silver wire
- Pages from botany books and ledgers
- Muslin
- Black seam binding
- Grey embroidery floss
- Snipping from an herb or another plant
- Black solvent ink
- Binder clip
- Distress Ink in Frayed Burlap and Tea Dye (Ranger)
- Drill with ¹⁄₁₆" (1.6mm) drill bit

- Fabric glue
- File
- Fleur-de-lis metal stamp
- Heat gun
- High-grit sandpaper or manicure block
- Jeweler's saw and blade
- Permanent marker
- Packing tape
- Rubber stamp
- Scrap wood
- Small clay cutters, round and oval

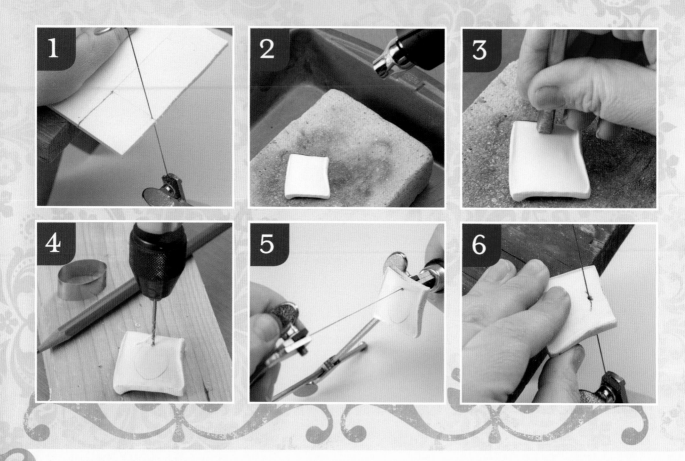

1. Using the jeweler's saw, cut a 1¼" x 1¼" (3cm x 3cm) square of Faux Bone. Use a file to remove any rough edges.

2. Place the firing brick into the pan. Hold a heat gun at least 6" (15cm) away and heat the Faux Bone in a circular motion. As the edges curl, adjust the heat placement until the piece resembles a well-curled book cover.

3. Heat the top center of the book cover again and stamp into the piece with a metal stamp. Let the Faux Bone cool before handling it.

4. Trace an oval shape using either a template or clay cutter as a guide. Using the drill with a ¹⁄₁₆" (1.6mm) bit, drill a hole in the center of the oval on the line.

5. Thread the saw blade through the drill hole, and saw out the oval.

6. As you do when sawing metal, use a firm but not forceful grip while moving at a steady but not fast rate.

Tip

The Faux Bone is meant to be altered to look like bone or ivory. However, when manipulated with heat, the substance takes on the appearance of porcelain.

If you get any dark edges from heating, you can sand the edges to bring back the white color.

7 Using the jeweler's saw, cut a 3" × 3" (8cm × 8cm) square of Faux Bone. With the heat gun and the firing brick, heat the piece until it is malleable. With the black solvent ink and rubber stamp, stamp into the Faux Bone while it is hot. Set it aside to cool. Using the saw, cut out two ovals and one circle.

8 Using the drill fitted with a ¹⁄₁₆" (1.6mm) drill bit, create a hole at the top and the bottom of each of the oval and round beads. Using the high-grit sandpaper or manicure block, sand any rough edges away, making sure to work in one direction.

9 Back the book cover with a strip of packing tape; pushing down on all sides to ensure that it is properly adhered. Prepare your work surface and mix and pour the resin (see Mixing Resin on page 8) into the center of the bezel until it is filled halfway. Set aside to dry for three hours. After three hours have passed, add the sprig of herb and a tiny bow created from the embroidery floss

into the bezel. Prepare a second batch of resin and pour it into the bezel. Allow the resin to cure for 24 hours.

10 Make a piece of resin paper from the book pages or ledger paper (see Resin Paper on page 10). Create the book pages using a mix of the resin paper and plain ledger paper. Cut the paper wider than the Faux Bone cover and clamp with a binder clip on the side that will not be bound.

11 Cut a piece of muslin approximately ½" × 1½" (1.5cm × 4cm). Place a line of glue across the stack of papers along the exposed edge. Place glue on the strip of muslin and press it into the glued pages. Move the binder clip to the binding side and let the glue dry.

12 Using the Frayed Burlap and Tea Dye inks, randomly place markings on the fabric binding of the book.

- -

Tip I added journaling to my ledger papers, journaling that corresponded with the character in my tale.

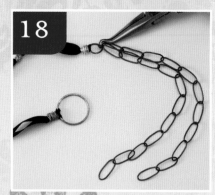

13 Stack the book cover and papers and hold them together with a binder clip on the side opposite the fabric binding. Using the drill fitted with the ¹⁄₁₆" (1.6mm) drill bit, create holes at the top and the bottom of the book.

Cut a 6" (15cm) piece of 24-gauge sterling silver wire that has been aged (see Patina Metal on page 20). Place the wire through the hole and center the wire so it is equal lengths on both sides. Twist the wire together three times.

14 Pull both pieces of wire down toward the bottom of the book, crossing them in the center to create an X. Feed the two ends through the hole, putting one end through the right and one end through the left.

15 Pull both wire ends through the holes and twist them together three times. Trim any excess wire. Trim the paper stack if needed.

16 Patina ten 5mm jump rings. Place the chain into the aging solution until it is black. Cut four 4"

(10cm) pieces of the 24-gauge sterling silver wire and place in the aging solution until dark.

Cut a 12" (30.5cm) piece of black seam binding and fold it in half. Place a 3mm aged jump ring onto it. Slide the jump ring to the middle of the folded ribbon.

17 Take one 4" (10cm) piece of the aged sterling silver wire and wrap it around the base of the seam binding right above the jump ring. Trim any excess wire.

18 Measure 1" (2.5cm) and repeat the wrap wire. Repeat one more time. At the last section, place one 2cm silver ring. Overlap the binding and wrap with the remaining piece of aged wire.

Open the 5mm jump ring at the end of the binding and attach two 6" (15cm) sections of the aged chain.

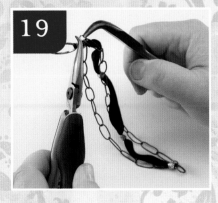

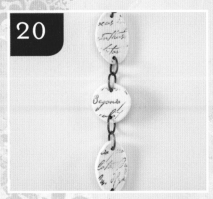

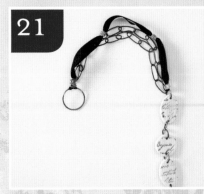

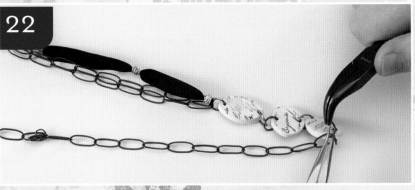

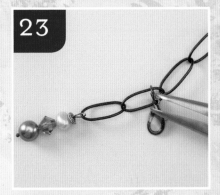

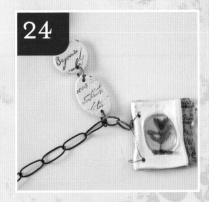

19 Thread an open 3mm jump ring through a few wires of the wire wrap that is just below the 2cm ring. Place both ends of the 6" (15cm) chain sections through the jump ring and close it.

20 Place a 5mm aged jump ring through each hole of the Faux Bone beads. Link them together.

21 Attach the Faux Bone section to the necklace using the 5mm fabric-wrapped jump ring.

22 Cut a length of aged chain. Add the chain to the open end of the Faux Bone section using a 5mm jump ring.

23 Create a headpin using 1" (2.5cm) of 24-gauge sterling silver wire (see Making Ball Headpins on page 24). Make a wrapped dangle with the pearls, crystal and headpin, adding the dangle to the end of the 7½" (19cm) silver chain before finishing the wrap.

 To the second link from the end of the chain, use a 3mm jump ring attach a clasp that has been aged.

24 Thread a 5mm jump ring through the wire binding of the book, and attach the book to the jump ring where the Faux Bone and chain section meet.

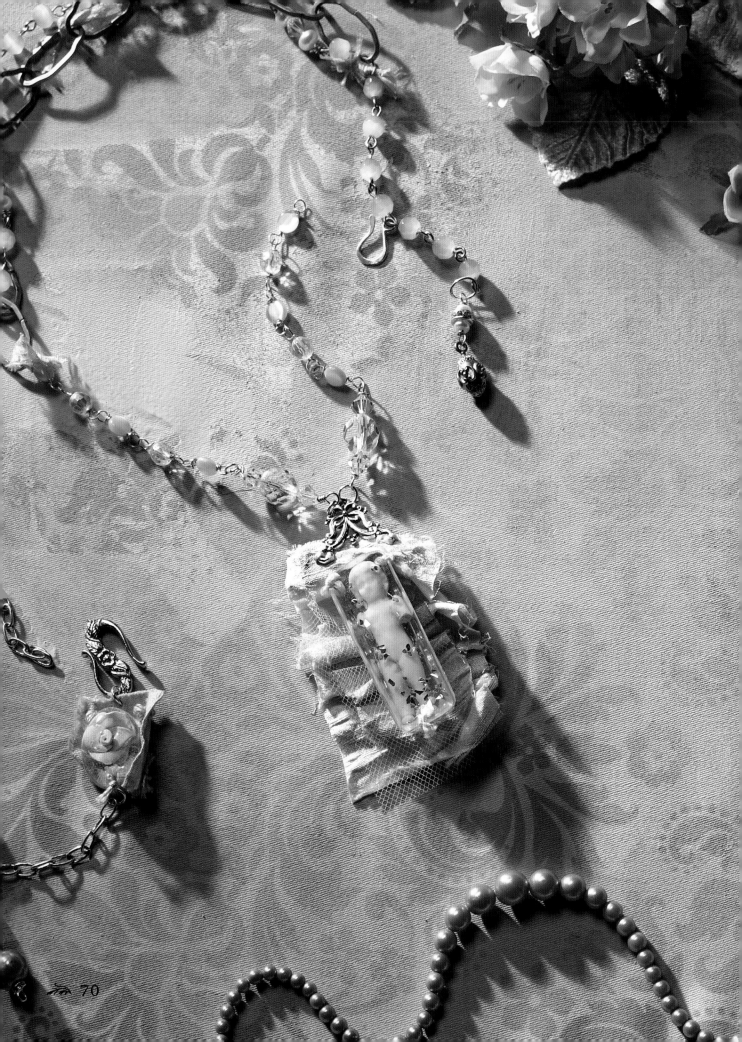

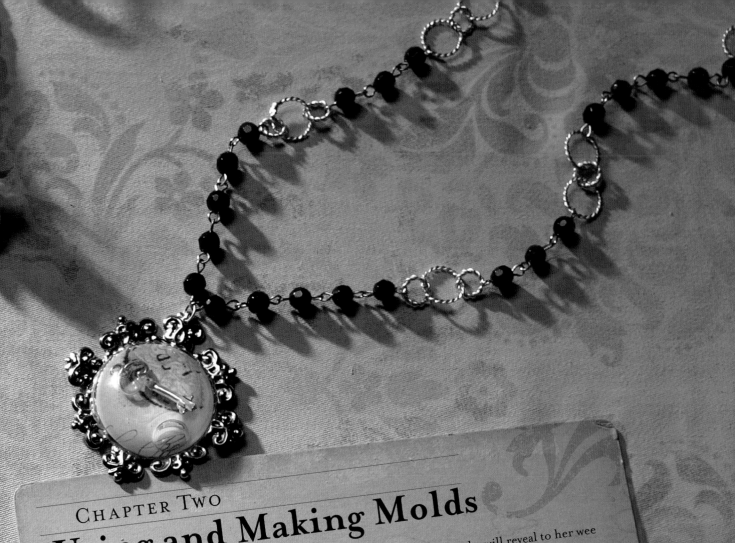

CHAPTER TWO
Using and Making Molds

Shhh. Charlotte's secret is within this section. Could it be that she will reveal to her wee ones the true nature and conclusion of her most famous tale? Resin and found objects forever embedded in a bit of resin act as windows to the past.

In this section, we will explore the unique character that molds have in taking simple objects and giving them life. We'll use purchased molds to dress up resin by adding paper, glass glitter and fashion plates from a time long past—our pieces will become the perfect adornments to cherish for a lifetime. Embracing our childhood memories is a must. Rolling molding putty in our hands satisfies something youthful within us all. Combining two parts to create one part that will soon become a vessel for treasures beckoning to be replicated is where the next portion of this journey unfolds.

A two-part process of coloring and pouring resin brings closure to a tale, while a sacred heart cast from a cherished antiquity offers a wee bit of adventure and intrigue. Layering, sanding, chain, and faux beach glass are all part of the next leg of our journey. While we have covered much thus far, there is an abundance of secrets yet to learn. Our tales continue to unfold as we dance through the pages of history, where hopes and dreams are conjured and realized.

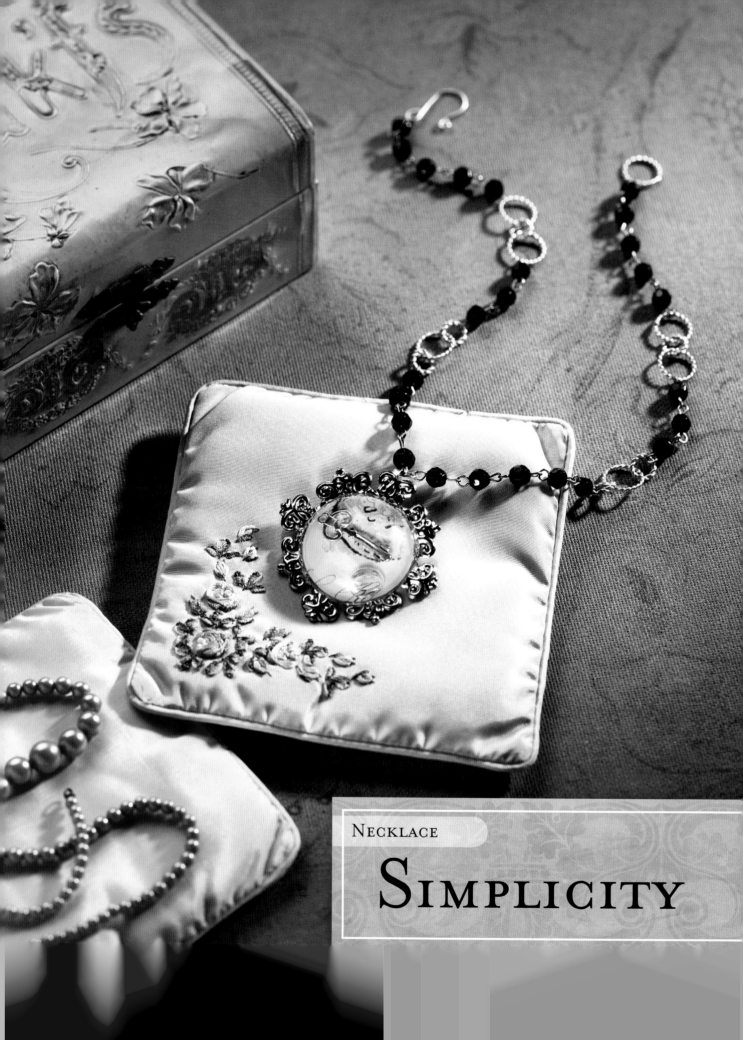

SIMPLICITY

The unsuspecting and rather unaware

crowd at Bath would never dare to dream that the work of a thief was soon to transpire. A criminal was amongst them, one with no conscience and who was absolutely empty of fear. The height of the season, when the who's who of London swooped into the countryside to take the cool climate and calming waters, was the perfect time to empty the coffers of the preoccupied members of the ton.

In disguise, he watched the house with diligence, waiting for the perfect moment to enter through the kitchen. There he wooed the scullery maid, convincing her to give him a tour of the house. They reached the gallery and he quietly slipped away, walking backward toward the study that would surely house the family safe. All the while, the young lass continued her narrative about the occupants and the many generations of her family that had worked in the home—poor girl.

Gently closing the door behind him, he went to work. Pulling books one by one from the book-shelf, he sought the well-hidden vault he knew existed. Book after book revealed nothing—his efforts were frantic. Knowing his time was running out—the young girl would surely come looking for him soon—he scanned the room, clenching his fists and letting a sigh of frustration escape him. Of course, he thought, he had neglected to check the space behind the well-placed hunting painting above the fireplace.

Pulling it from the wall, he found it—there! Fidgeting with the lock for a mere second, it opened, and inside he found three pieces tied together with a scarlet ribbon. Three pieces that spoke literally of simplicity as the wee tag on the ribbon read: "Necessity is the Mother of Invention but Simplicity is the Mother of All Beauty."

A large crash startled him and the study door flew open. She held the paper up to the light, lightly blowing on the ink to ensure that it would dry quickly—it was not yet the end of this tale!

MATERIALS

- Resin reticule (see page 8)
- Jeweler's reticule (see page 11)
- Clasp reticule (see page 14)
- Firing reticule (see page 24)
- Charms
- Silver charm
- Black rosary chain
- Two metal stampings
- One 10mm jump ring
- One 4mm jump ring
- 20-gauge sterling silver wire
- Silver bale
- Ephemera
- Awl
- Drill with 1/16" (1.6mm) drill bit
- 3/16" (5mm) dowel
- 1/2" (5cm) dowel
- E600
- Hammer
- Packing tape
- Plastic paint palette
- Scrap wood
- Soft cloth or towel
- 800-grit sandpaper

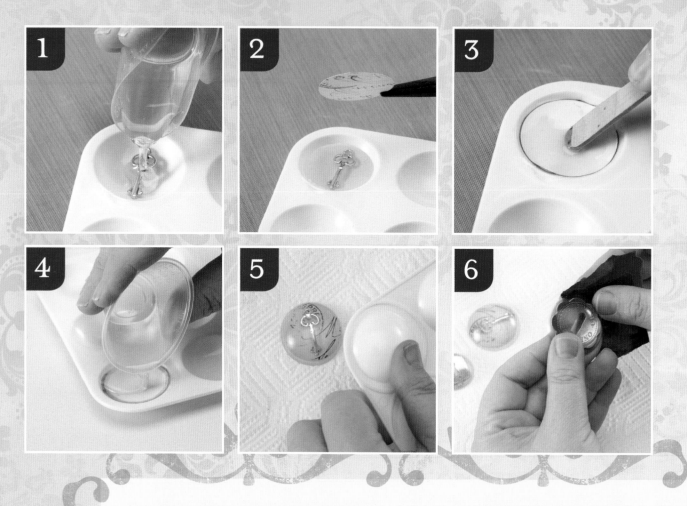

1. Spray mold release into each of the palette pots you are using and set them aside to dry. Prepare your work space and place a silver charm into the empty pot. Center the item, and then mix (see Mixing Resin on page 8) and pour the resin over the charm, until the pot is three-fourths full.

2. Cut a piece of ephemera to the size of the back of the bezel and place it facedown into the poured resin.

3. To create a bubble in the resin, use a craft stick to press down firmly on the back of the paper. Repeat this process in the remaining palette pots. Set aside for four hours to dry.

4. When the first layer is tacky to the touch, pour an additional layer of resin into each bezel. This will create a floating effect for the items you added in step 1.

5. Lay a soft towel or cloth on a flat work surface. Lay the palette upside down on the towel. Press firmly on the back of each palette pot, releasing the bezel. You may need to apply additional pressure with a hammer.

6. Repeat step 1, this time filling the pots completely, for two more bezels, for a total of three bezels. After all the bezels are released examine the edges. Sand any rough edges with 800-grit sandpaper.

--

Tip Multiple pieces can be created at one time using this method of pouring.

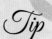

7 Place the stamping on the scrap wood. Using the awl and hammer, create an indentation for the drill to penetrate.

8 Using the drill with ¹⁄₁₆" (1.6mm) drill bit, drill through the point created by the awl.

9 To add a metal stamping to the back of the bezel, sand the back of the resin piece slightly to rough it up. Place a dollop of E600 on the bezel and let it sit for two minutes. Adhere the bezel to the metal stamping and allow to dry for 24 hours.

10 Thread the 4mm jump ring through the drilled hole (see Opening and Closing Jump Rings on page 12).

11 Drill the remaining resin pieces. Place the bezel onto a piece of wood and add a piece of packing tape over the bezel to secure it. Using a drill fitted with a ¹⁄₁₆" (1.6mm) drill bit, drill a hole through the top center.

12 With the silver bale in the open position, place the teeth through the drilled hole. Using a pair of flat-nose pliers, squeeze the bale to secure it.

Tip When pulling the drill bit out of the resin, do not pull the bit straight out; instead use the reverse function on the drill.

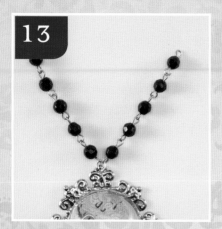

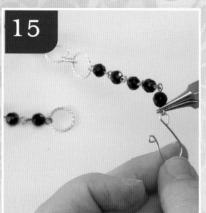

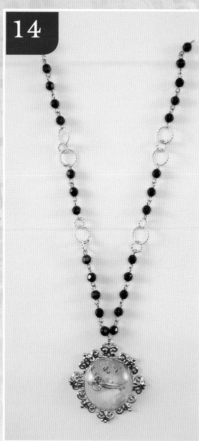

Tip

Simple embellishments like twisted wire chains and purchased rosary beads make this project very straightforward and easy to complete.

13 Use the 4mm jump ring on the top of the metal stamping to attach it to the center of a 2" (5cm) section of rosary chain.

14 Create a piece of twisted wire using a 24" (61cm) piece of 20-gauge sterling silver wire (see Twisting Wire on page 21). Using the twisted wire, create six ³⁄₁₆" (5mm) jump rings and seven ½" (1.5cm) jump rings (see jump ring instructions on pages 11–12).

Create two links composed of two ³⁄₁₆" (5mm) twisted wire jump rings on either side of one ½" (1.5cm) twisted wire jump ring. Solder the links shut (see Soldering With a Torch on page 24). Attach the silver chain to sections of the rosary chain. Do this until the piece is the desired length.

15 Make a hook using a 1" (2.5cm) piece of 20-gauge sterling silver (see Making a Simple Hook Clasp on page 14). Attach this to the rosary chain. Attach one 10mm jump ring to the adjoining rosary links.

To the remaining resin pieces, repeat rosary chain and twisted links in the desired configurations. I made another necklace and a bracelet to complete the set (pictured right).

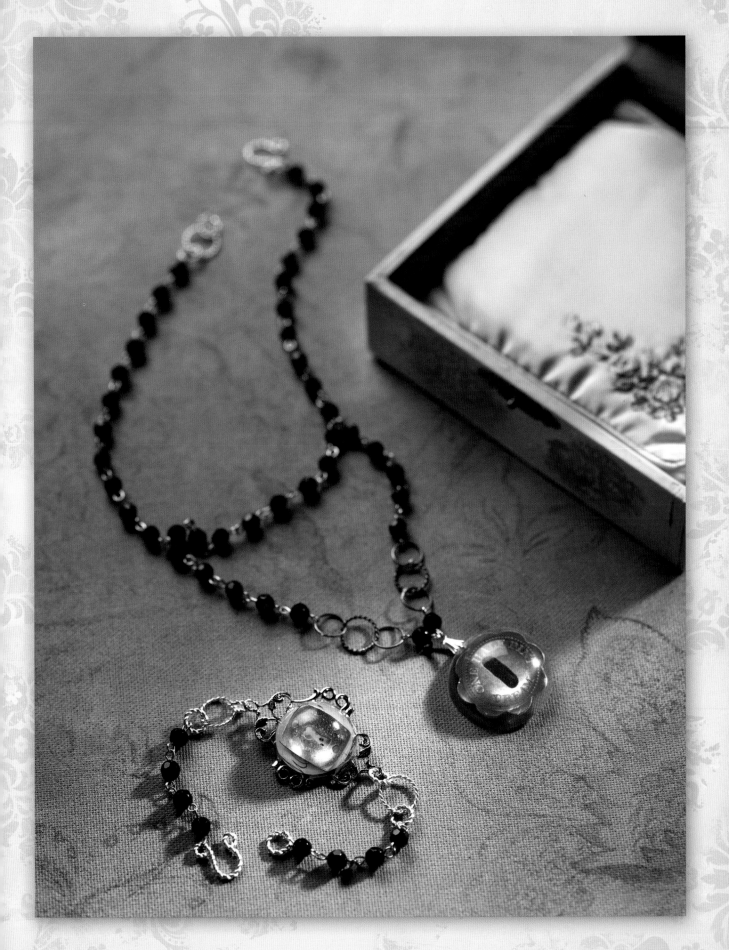

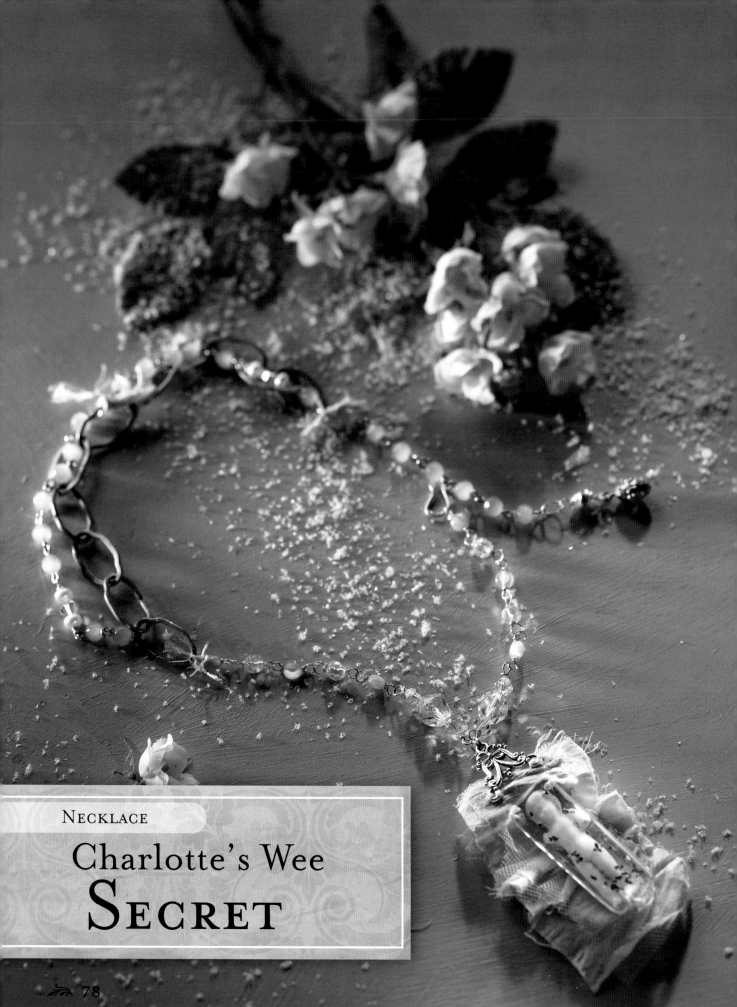

NECKLACE

Charlotte's Wee
SECRET

Looking down at their angelic faces,

she could not resist as the little darlings she adored called to her, squealing, "Tell us the tale of Wee Charlotte, please!" She wondered how they could endure hearing the tale again, for these wee ones had heard it more times than their ages combined. Taking her place on the stool between the beds, she began the tale.

Many years ago, in a merchant's village, lived a girl known to her family and friends as Wee Charlotte because she was very petite in stature and demure in disposition. Charlotte wanted for nothing; as the only daughter of a wealthy merchant and his wife she was given every trinket and bauble she desired. One cold winter night, a ball was to be held—a ball that the surrounding townspeople would attend, a perfect social opportunity to see and be seen. As the light of day grew closer to its slumber, Charlotte's parents begged her not to travel to the ball in the open carriage. However, in her vanity and desire to be seen, she disobeyed their request: Only in the open carriage would her finery be seen as she traveled the dusk-laden roads.

Waving farewell to her parents, she placed her hand in that of her true love, allowing him to help her into the carriage. It was not long before Charlotte was chilled through, and she then knew that disregarding her parents' wishes had been a terrible notion. The driver pushed the horses through the snow-covered roads as quickly as possible, but time seemed as if time were at a standstill. Seeking warmth, Charlotte laid her head upon her love's shoulder; a silent tear fell from her lovely eyes, before they closed on their own volition.

Calling a halt to the nonsensical journey, Charlotte's love bent to tell her of his plan to return. It was then that he realized his darling Wee Charlotte had perished; she was well and truly frozen. A silent tear lay frozen on her creamy cheek, almost as if a crystal had been placed upon it.

Bending to pull the covers over the little girls, she giggled to herself. She knew that one day they would ask what the secret was to the tale. Until that day, she would not tell them that she was actually Wee Charlotte, and although she felt as though she would freeze to death that dreadful night, she did not.

MATERIALS

- Resin reticule (see page 8)
- Jeweler's reticule (see page 11)
- Six 3mm light blue flat round beads
- Four 4mm blue bicone crystals
- Four 3mm iridescent round crystals
- Four 3mm cushion pearls
- Two 10mm clear vintage crystals
- Two 4mm clear bicone crystals
- Two 2mm cushion pearls
- One 2mm crystal rondelle

- Silver cone charm
- Frozen Charlotte doll
- 9½" (24cm) blue rosary chain
- 8½" (22cm) length of silver chain
- Two 5mm jump rings
- 22-gauge round sterling silver wire
- 10mm silver clasp
- 2-to-1 silver filigree connector
- Silver glass glitter
- Grey seam binding

- Grey silk shantung
- Light blue silk shantung
- White tulle
- Crème embroidery floss
- Embroidery needle
- Drill with a ⅛" (3mm) drill bit
- Mold release
- Rectangle mold
- Scrap wood
- Toothpick

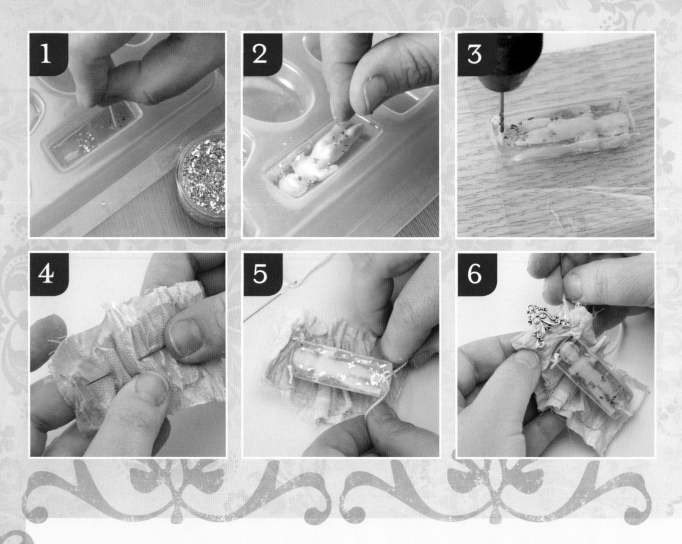

1. Spray mold release into the mold and let it dry. Prepare your work surface. Mix ½ oz. (15mL) of two-part resin and pour it into the rectangle mold (see Mixing Resin on page 8). Sprinkle ⅛ teaspoon of silver glass glitter into the resin. Push this down with a toothpick into the mold. This will be the back of the charm.

2. Place the frozen Charlotte face down into the resin, using the toothpick to maneuver the doll into place. Add additional glass glitter to the top of the doll. Allow the resin to cure for 24 hours.

3. Remove the resin charm from the mold by gently pressing on the back of the mold. Tape the resin piece to the scrap wood. Using a drill with a ⅛" (3mm) drill bit, drill one hole at the top of the charm on both the left and right side. Repeat in the center bottom of the charm.

4. Cut a 2" × 4" (5cm × 10cm) piece of light blue silk shantung, a 1" × 3" (2.5cm × 7.5cm) piece of grey silk shantung and 1½" × 2½" (4cm × 6cm)

piece of white tulle. Stack the fabric grey, blue, tulle.

Thread an embroidery needle with crème embroidery floss. Gather the fabric and hold the layers together as you place a running stitch through the center gathering. Secure with a knot and trim the excess thread.

5. Place the charm on top of the fabric (tulle facing up). Attach the charm going through and around the two top holes first, going through all layers of fabric. Tie a knot to secure the stitch and trim the excess thread. Secure the charm through the hole in the bottom in the same fashion.

6. To the top of the fabric, sew the 2-to-1 silver filigree connector using the embroidery floss and needle. Secure with knots to the back of the fabric. This is the bale for the necklace.

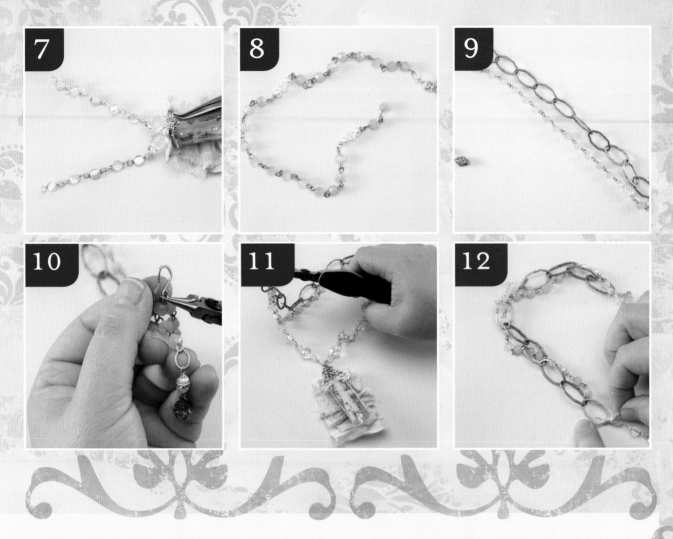

7 Using the 22-gauge round sterling sliver wire, make a wrapped link using a 4mm blue bicone crystal, a 10mm clear vintage crystal and an additional 4mm blue bicone crystal. Off this link, create a wrapped chain (see Making a Wrapped Link on page 17) using the following beads: 3mm flat blue bead, 3mm iridescent round crystal, flat, crystal, flat. Repeat for a second identical chain segment.

Attach the crystal chains to the bale using the 5mm jump ring (see Opening and Closing Jump Rings on page 12).

8 Create two pearl wrapped links using one 3mm cushion pearl, a 4mm crystal bicone and an additional 3mm cushion pearl for each link.

Assemble this chain segment using the rosary chain and the pearl wrapped links, following this pattern: Two links of blue rosary chain; one pearl wrapped link, 5½" (14cm) section of blue rosary chain, one pearl wrapped link, 3½" (9cm) section of blue rosary chain.

Create a wire-wrapped link using a 2mm cushion pearl, a 2mm crystal rondelle and a 2mm cushion pearl, adding the silver cone charm before closing the final loop. Using a 5mm jump ring, attach the pearl and crystal wrapped link to the end of the blue rosary chain.

9 Cut (or open) an 8½" (21.5cm) strand of silver chain. Attach one end of the chain to the first rosary link attached to the blue chain (open the rosary link as you would a jump ring). Attach the other end of the chain to the first rosary link placed at the last pearl and crystal link.

10 Counting from the silver cone charm, attach the clasp through the top of the third rosary link.

11 Attach one end of the chain to the first rosary link attached to the crystal chain.

12 Cut three 1" (2.5cm) strips of grey seam binding and tie at each end of the silver chain. Add the third piece of seam binding to the center of the silver chain.

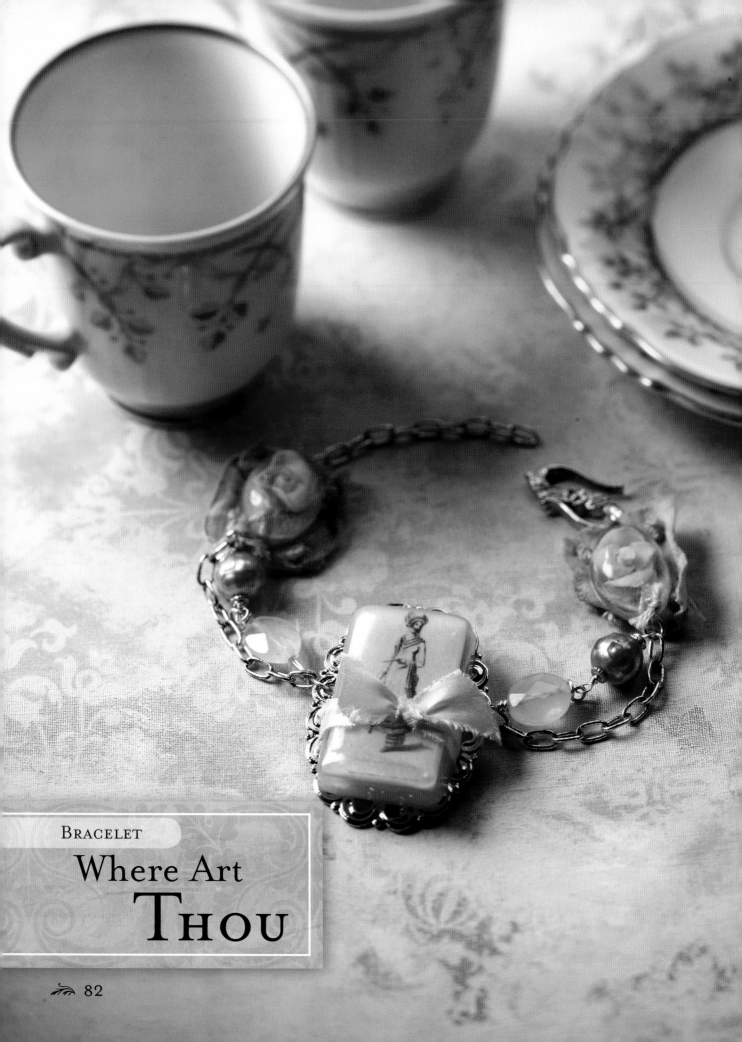

Where Art
THOU

My Dearest Girl,

I write to you with not only a full but also a heavy heart. It has been four weeks since I last hugged you, shared a laugh with you and poured a pot of tea for the two of us. Our journey has at times been full of adventure, while other times have been lackluster and less than fulfilling.

I fear the dig sites we seek have been pilfered by those who have come before us. It seems they have a complete lack of respect for the history of these places. But the sites we have seen seem to be far older than I expected. With any luck, we will soon find the structure we seek. I have high hopes that I will return with a bounty of treasures for the museum as well as the antiquities commission.

Although the journey has been a challenge, there are many with us that feel the presence of a woman is nothing short of a bad omen. If your father were here, he would put the situation to rights. We will continue to search for the treasures we seek buried deep in the earth, and for now I will hold on to hope and determination. I wear my treasure upon my wrist each day thinking of you, looking forward to the day you will join us.

Truly,

Mother

MATERIALS

- Resin reticule (see page 8)
- Dyeing reticule (see page 25)
- Two 10mm oval pink quartz
- Two 8mm faceted pink pearls
- Silver chain
- Four 5mm sterling silver jump rings
- 22-gauge sterling silver wire
- Clasp
- Oval metal stamping
- Fashion plate image

- Muslin
- Pink silk ribbon
- Grey embroidery floss
- Two ¾" (2cm) oval molds
- One 1" x 1½" (2.5cm x 3.8cm) rectangle mold
- Acrylic rolling pin
- Drill with 1/16" (1.6mm) drill bit
- E600
- Embroidery needle

- Fabric glue
- Mold release
- Pale pink acrylic paint
- Pale pink polymer clay
- Scrap wood
- Tape
- Toothpick
- Tweezers

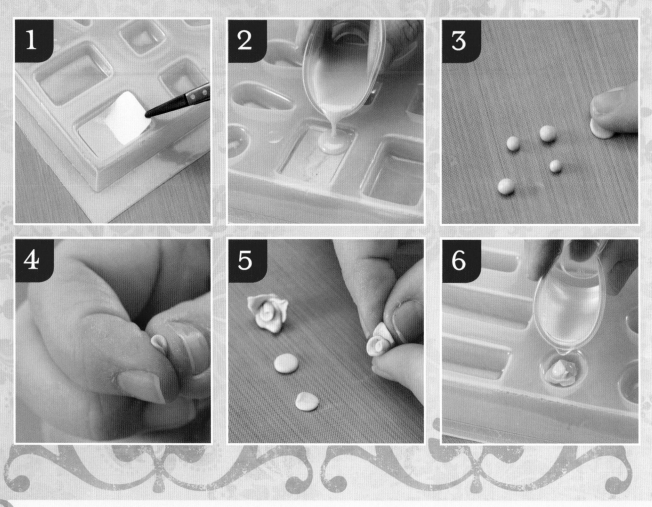

1 Spray mold release into the rectangle mold and two oval molds. Set aside to dry.

Prepare your work surface. Mix ½ oz. (15mL) of two-part resin (see Mixing Resin on page 8) and pour it into the rectangle mold until it is one-fourth full. Place the image of the fashion plate into the resin. Use the tweezers to press the paper into the resin. Some resin may spill over the side; just wipe it from the surface with a paper towel. Let the resin cure for eight hours.

2 Prepare your work surface. Mix ¼ oz. (7.5mL) of two-part resin and add a drop of pale pink acrylic paint, stirring thoroughly with a toothpick (see Adding Color and Inclusions to Resin on page 8).

Pour the colored resin into the rectangle mold until the resin reaches the top of the mold. Let the resin cure for 24 hours.

3 Over the nonstick craft sheet, condition a 1" × 1" (2.5cm × 2.5cm) piece of pale pink polymer clay and roll it into a ball. Create five small balls

measuring in size from 4mm to 1mm. Create the center petal by pressing on the smallest ball until it is flat.

4 Take the flattened clay between your forefinger and thumb and roll the sides together; this will be the center of the flower.

5 For the petals, repeat the process of flattening a clay ball; pressing the flattened clay onto the center piece and shaping the clay to resemble a petal. Repeat this process until you have used all five balls. Bake the clay according to the package instructions.

6 Prepare your work surface. Mix ½ oz. (15mL) of two-part resin and pour it into two ¾" (2cm) oval molds until they are one-fourth full. Into the first resin layer place a polymer clay flower.

After the roses have been placed in the molds, fill the remainder of the molds. Let the resin cure for 24 hours.

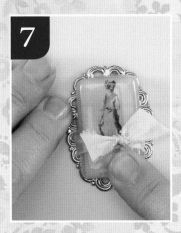
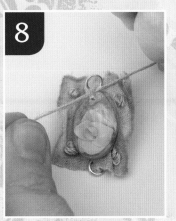
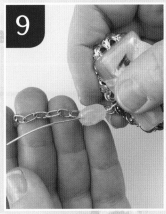
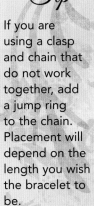

Tip

If you are using a clasp and chain that do not work together, add a jump ring to the chain. Placement will depend on the length you wish the bracelet to be.

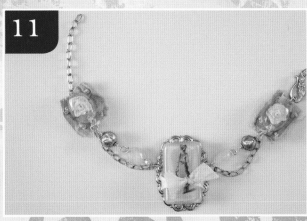

7 Remove the rectangle bezel from the mold. Sand any rough edges that may be present on the bezel. Tie a scrap of pink silk ribbon around the bottom portion of the bezel (see Dyeing Ribbon on page 25). Place a drop of E600 on the back of the bezel as well as the front of the metal stamping. Set aside for two minutes. When the two minutes have passed, press the back of the bezel onto the metal stamping. Set it aside to dry for eight hours.

8 Tape the oval bezel onto the scrap wood. Using a drill fitted with a 1/16" (1.6mm) drill bit, drill a hole at the top of each of the oval bezels (see Drilling into Resin on page 9).

 Cut or tear a piece of dyed muslin measuring roughly 1" × 1" (2.5cm × 2.5cm). Place a small drop of fabric glue on the back of the oval bezel and adhere it to the scrap of fabric.

 Using the embroidery needle and grey embroidery floss, add four French knots to the muslin. Also create a knot through the hole of the bezel, tying the knot in the front of the piece. Place a 5mm jump ring through the knot. Make a small hole at the bottom of the fabric with an embroidery needle and attach one 5mm jump ring. Repeat this with the remaining oval charm.

9 Cut a 4" (10cm) piece of 22-gauge sterling silver wire. Cut a 2" (5cm) piece of silver chain. Begin a wire-wrapped link, threading the loop through the side of the rectangle bezel backing, and thread on the end link of the 2" (5cm) chain before closing the loop. Thread a 10mm oval pink quartz onto the wire and finish the wrap.

10 Make another wrapped link using a 4" (10cm) piece of 22-gauge sterling silver wire and a pink pearl, threading the beginning loop through the last loop of the quartz link. Open the jump ring on one side of an oval resin charm and thread it through the pearl link. Attach the free end of the piece of 2" (5cm) chain and close the jump ring.

 Repeat this step on the other side of the rectangle bezel.

11 To the end jump ring on the right side, attach the clasp. To the opposite side attach 2" (5cm) of chain; this will allow the bracelet to be adjustable.

My Heart's POEM

The hours seemed to pass as slowly

as weeks and minutes felt as full as days to him. The knowledge that the missing jewels would soon be in his hands not only thrilled him, it also stirred trepidation in his heart.

How many years had it been since he had last seen the necklace that his mother cherished so much? A necklace full of beauty and at the same time full of secrets. He did not know where the piece had come from, as his mother never shared anything about it with him while she lived. He'd pondered the idea that it may not have been a gift from his father. While he hoped his parents had affection for one another during their short time together, he was unsure because their marriage, like many others, had been arranged.

Looking to the mantelpiece once more, he sighed. The clock chimed, announcing the time as two in the afternoon. The sound of an approaching horse grabbed his attention. He left his library, making his way to greet the rider before anyone else had a chance to intercept him. He received the package gratefully, sending the rider to find sustenance before riding back out.

The package burned his hands as he walked through the house—the contents seeming to jump in their wrapping. Locking the study door behind him, he took his place in the large chair that faced the fireplace. Peeling back the layer of protective leather, he found the piece to be exactly as it was in his youth. A large heart was the centerpiece to an array of pearls, topaz and garnets. Lifting the necklace, he watched a small scrap of parchment fall into his lap. Holding the parchment to the light, he read the words aloud.

You have my heart.
You have my soul.
You are my life.
Forever you will be MY heart's poem.

Recognizing his father's writing, he let out the breath he had been holding. All was as it should have been.

MATERIALS

- Resin reticule (see page 8)
- Jeweler's reticule (see page 11)
- Aging reticule (see page 20)
- Dyeing reticule (see page 25)
- Nine 4mm round garnets
- Five 8mm natural-colored potato pearls
- Three 10mm copper jump rings
- Three 5mm bronze potato pearls
- One 18mm faceted garnet
- One 10mm faceted smoky topaz bead

- One copper clamshell
- One 20mm bronze chain link
- Nine 22-gauge gunmetal headpins
- 24-gauge gunmetal wire
- 20-gauge gunmetal wire
- Mica powder
- Polymer clay
- 2 yards (1.8m) of 1" (2.5cm) wide raw silk Ribbon
- Silk bead cord #1

- Clear packing tape or clear shelf paper
- Craft knife or ¾" (2cm) heart-shaped cookie cutter
- Crimson dye
- Drill with ¹⁄₁₆" (1.6mm) drill bit
- Mold release
- Quinacridone Crimson Fluid Acrylic Paint (Golden)
- Straight pin or T-pin
- Two-part mold putty

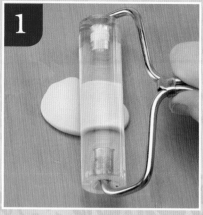

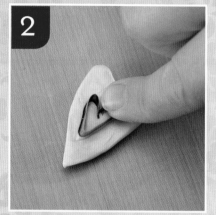

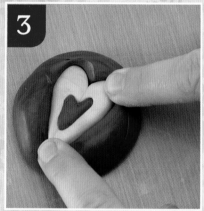

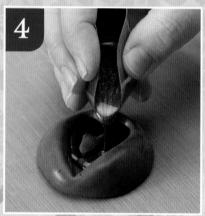

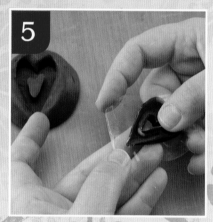

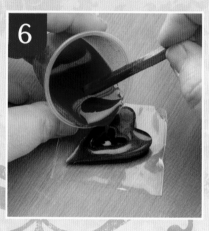

1 Condition a 1" (2.5cm) ball of polymer clay, kneading it until the clay is pliable and easy to work with. Roll the conditioned clay out to a ½" (1.5cm) thickness.

2 Shape the clay into a heart. From the center of the heart, cut out a smaller heart with either a craft knife or a cookie cutter. Bake according to the package instructions.

3 Prepare your work surface and create a resin mold with two-part mold putty (see Working With Two-Part Putty on page 10). Press the polymer clay heart into the putty, smoothing and shaping the putty as needed. Set it aside to dry.

4 Pop the polymer clay heart from the mold. Spray the mold with mold release and let it dry.

 Mix the resin in one batch, approximately ½ oz. (15mL) total. Add approximately ¼ teaspoon of mica powder to the resin. Using a gentle folding motion, mix the mica thoroughly until the resin is saturated (see Adding Color and Inclusions to Resin on page 8).

 Pour the resin into the mold. Let it cure for 24 hours.

5 Remove the resin heart from the mold and back it with the clear packing tape or clear shelf paper, pushing firmly to ensure a good seal.

6 Mix the resin in one batch, approximately ¼ oz. (7.5mL) total. Add a drop of Quinacridone Crimson fluid acrylic paint to the resin until the resin is saturated. Pour it into the center of the heart. Let the resin cure for 24 hours.

Tip The clay will likely shrink a bit after baking, so make the heart slightly bigger than you want the finished product.

Tip If you get packing tape residue on your resin piece, baby wipes will remove it.

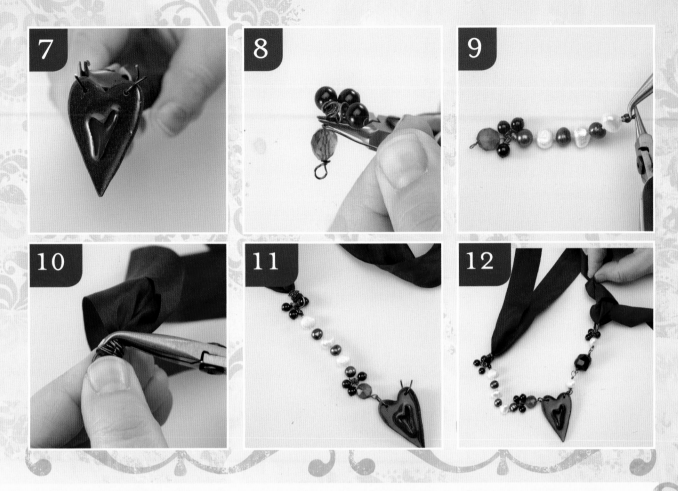

7 Remove the tape from the back of the resin heart. Use a piece of packing tape to secure the resin piece to the surface. Using a hand drill fitted with ¹⁄₁₆" (1.6mm) drill bit create a hole on both sides at the top.

Add one 10mm copper jump ring to each hole drilled (see Opening and Closing Jump Rings on page 12). Leave the jump rings open for now.

8 Using nine 22-gauge gunmetal headpins and nine 4mm round garnets, make nine wrapped dangles (see Making a Wrapped Dangle on page 16).

Create a wrapped link using a 3" (8cm) piece of 24-gauge gunmetal wire and one 10mm smoky topaz bead. Before wrapping the link closed, slide on three garnet dangles (see Making a Wrapped Link on page 17).

9 Cut a 3" (8cm) piece of silk bead cord #1. Knot it to the looped end with the garnet dangles. Add pearls to the cord in the following order (see Stringing Pearls on page 18): 5mm bronze potato pearl, 8mm natural potato pearl, bronze, natural, bronze and natural. End the pearl chain with a copper clamshell. Attach the clamshell to one 10mm copper jump ring.

10 Fold 2 yards (1.8m) of the dyed silk ribbon (see Dyeing Ribbon on page 25) in half and thread the ribbon through the jump ring at the top of the strung pearls.

Cut 12" (30.5cm) of 20-gauge gunmetal wire. Wrap the wire around the base of the ribbon where it meets the top of the jump ring eleven times. Trim any excess wire.

11 Open the jump ring where the ribbon meets the pearls and thread on three garnet dangles. Place the whole cord onto the left side of the pendant and close the jump ring.

12 Make a wrapped link chain using the following beads: one 8mm natural potato pearl, one 18mm faceted garnet, and one 8mm natural potato pearl; add three garnet dangles before wrapping the final loop.

Attach the chain created in step 12 to the right side of the pendant. Using the flat-nose pliers, attach one 20mm bronze commercial chain link to the potato pearl link.

Through the bronze chain link, thread the remaining ribbon, tying it into a knot or bow. Trim the excess ribbon.

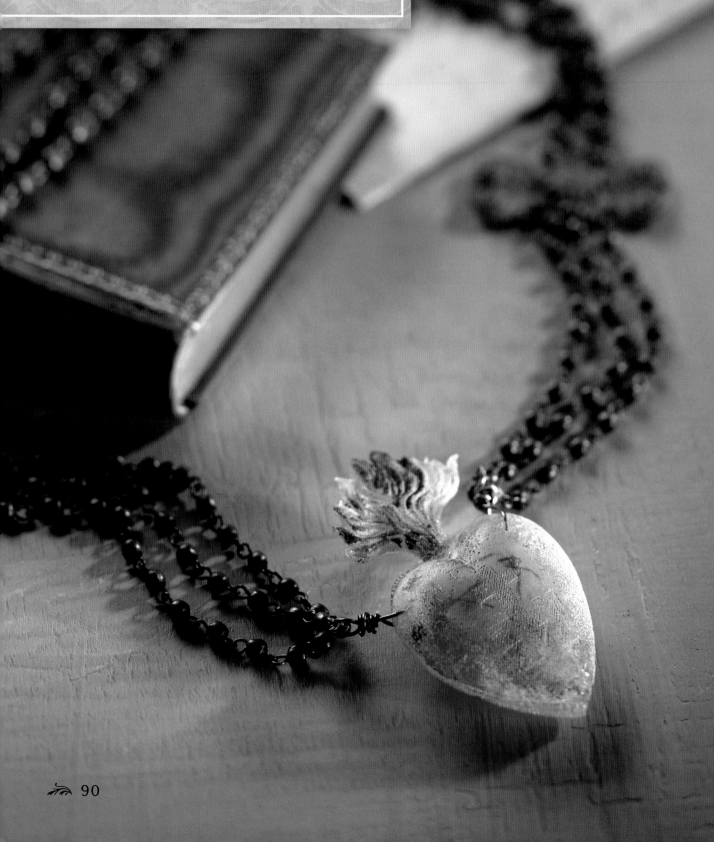

She Speaks of TRUTH

Holding her finger to her lips, she

shushed her little ones once more. Silence was going to be hard to find this evening. Closing the door behind her, she made her way toward her sitting room, anxious to spend time looking through the box of treasures she had found in the attic a few days ago. As her husband was in London for the remainder of the week, she had only a handful days to pursue her investigation.

She sat in her favorite chair and pulled the box from under it. Pulling the charred papers from the box, she begin to read.

November 13, 1615

Today winter arrived. Snow covers the ground and the birds have ceased to chirp outside my window. I cannot help but wonder when word will come that I might travel safely once again. The Sisters tell me I am to remain here safe with them, and the time will eventually come when I might safely be united with my true love and our marriage will take place.

For now I will find comfort in the words of Shakespeare, for his sonnets speak to my heart and at times offer me hope for what might be in the future. The sisters are not comfortable with some these romantic notions.

November 14, 1615

A large wooden domed box arrived today. A simple note penned in his hand was attached. Inside lay a book; a book of new sonnets from the master of romantic comedy himself. The inscription inside simply reads, "for now this will keep us together." I can only dream he is right.

November 25, 1615

The soldiers have found me. It seems the crown is ready to acknowledge my existence. I hold within my hands the sacred heart that holds the truth of who I am. As it lies upon my skin, it fills me with the knowledge that soon I will be united with my true love. For now, I leave to ride quickly.

The sound of a door closing pushed her back into reality. He was home early, no doubt to surprise her. Putting the treasures back into the box, she closed the lid. For now she would have to be satisfied with what she had learned tonight. Later she would discover the rest of the tale.

MATERIALS

- Resin reticule (see page 8)
- Molding reticule (see page 10)
- Jeweler's reticule (see page 11)
- Aging reticule (see page 20)
- Vintage ball chain (purchased)
- Vintage metal stamping with open areas to connect chain

- 20-gauge gunmetal wire
- Ginger
- Paprika
- Book page
- Red thread
- Antique sacred heart
- Burnt sienna paint

- Cardboard
- Craft knife
- Drill with $\frac{1}{16}$" (1.6mm) drill bit
- E600
- Glue gun with melt sticks
- Jeweler's saw
- Small dowel

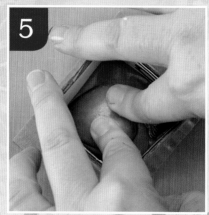

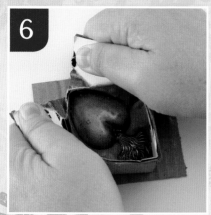

1 Cut one 4" × 2" (10cm × 5cm) piece of cardboard. Score the cardboard with a craft knife every 2" (5cm).

2 Fold the cardboard to resemble a box. Place the craft mat on the work surface. Using a glue gun, glue all four corners of the box.

3 Cut a 4" × 4" (10cm × 10cm) piece of cardboard using a craft knife. Glue the 4" × 4" (10cm × 10cm) cardboard to the bottom of the box using the glue gun.

4 Working on the craft mat, quickly knead equal parts of the two-part putty until it is completely mixed. Roll the putty into a ball and press it into the box.

5 Press one side of an antique sacred heart into the mold. Let it dry for 20 minutes.

6 After the mold has dried, remove the mold (with the object still within in it) by placing a cut at one of the box corners and ripping off the sides of the box.

Tip Your box size will depend on the object you're casting. Measure the object and add at least ¼" (6mm) on all sides to the box measurements.

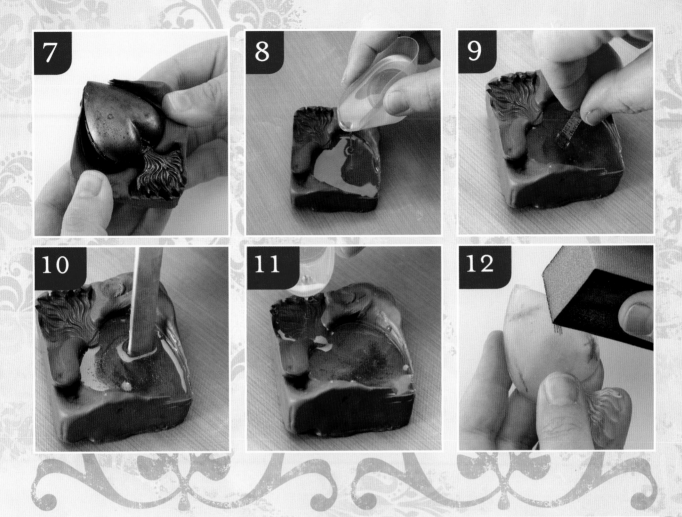

7 Remove the sacred heart by gently pressing on the back of the mold while pulling the sides of the putty.

 Repeat steps 1–7 to create a mold of the other side of the sacred heart.

 Create a piece of resin paper (see Resin Paper on page 10) from the book page.

8 Mix ½ oz. (15mL) of resin (see Mixing Resin on page 8), stirring vigorously to introduce air bubbles. Pour the resin into both molds until the each is filled about halfway.

9 Using the scissors, cut the resin paper, choosing words that you like. Using your fingers, place a scant amount of ginger, paprika and the resin paper words into one side. With a craft stick, move the spice and resin paper until they are in the center of the heart.

10 To the other mold, add the scraps of red thread, as well as bits of paper if you desire. Using a craft stick, adjust the threads and paper to ensure they do not clump together.

11 Fill the remainder of the molds with resin and let them cure for 24–36 hours.

12 After the resin has set, release each heart half from its mold. Sand the edges of the resin pieces. If needed, sand the flat backs (what will be the inside of the two pieces) with a nail buffer.

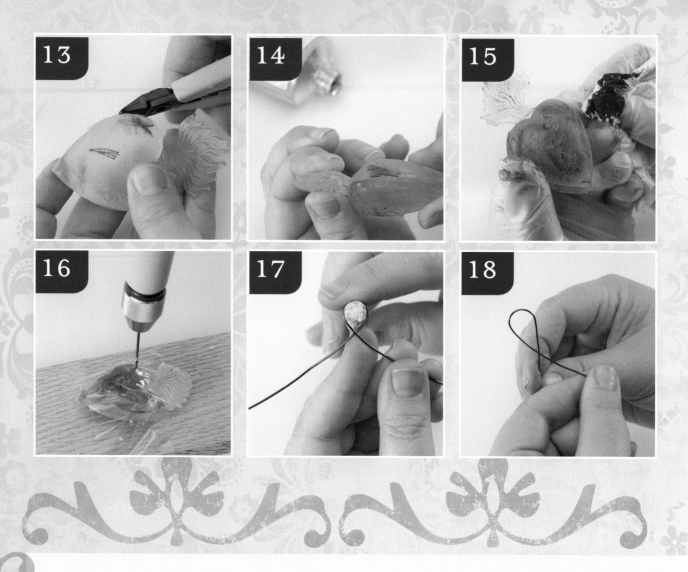

13 If necessary, use the wire cutters to trim the excess resin from the edges of the heart pieces.

14 Place adhesive on each side of the heart and let it sit for five minutes. Place the two halves together on a flat surface, propping up the flame portion of the heart, and let dry for 24 hours.

15 After the glue has dried, place a dollop of burnt sienna paint on a paper towel and rub it into the edges, flames and any engravings on the heart. Rub off the excess with the paper towel and let the paint dry. After the paint has dried, run a nail buffer over the surface to add dimension. Repeat this process on the back.

16 Tape the resin heart to the scrap wood. Using the drill fitted with ¹⁄₁₆" (1.6mm) drill bit, drill two holes at the top of the heart, one on each side. If needed, thread a long embroidery needle through the holes to clear any of the glue that may go back on itself.

17 Cut two 5" (13cm) pieces of 20-gauge gunmetal wire. Bend the center of the wire and create a large loop around a small dowel. (This loop should be large enough to fit the drilled holes in the heart; see step 19 for visual reference).

18 Pull the wire gently apart to keep the curve in the center of the wire.

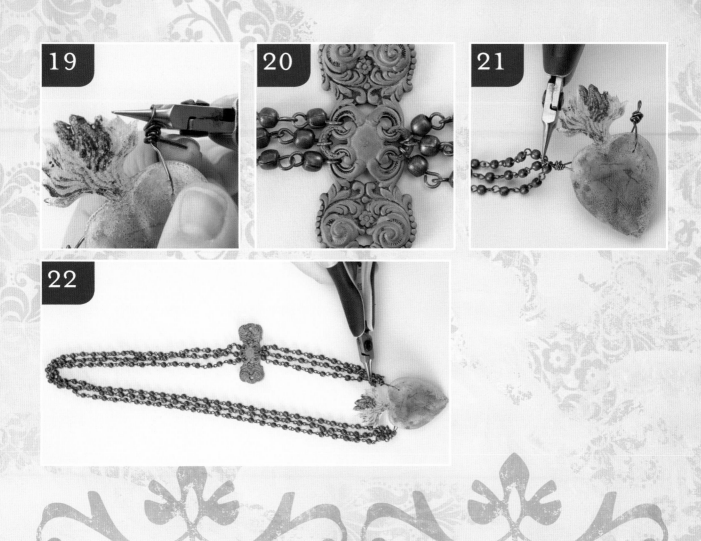

19 Place the loop through the drilled hole of the heart. Wrap the remaining wire. Turn the remaining wire in a loop toward you, and close the loop. Repeat this on the adjoining side (See Making a Wrapped Link on page 17).

20 Patina the vintage metal stamping and the purchased ball chain (see Patina Metal on page 20). Attach three 22" (56cm) lengths of the ball chain, one chain to each connector. To the bottom of the metal stamping attach an additional three lengths of vintage ball chain measuring 6½" (16.5cm).

21 To the left wrapped loop attached to the heart, attach three 22" (56cm) strands of vintage ball chain.

22 Using round-nose pliers, attach the three shorter chains to the right wrapped-wire loop on the heart.

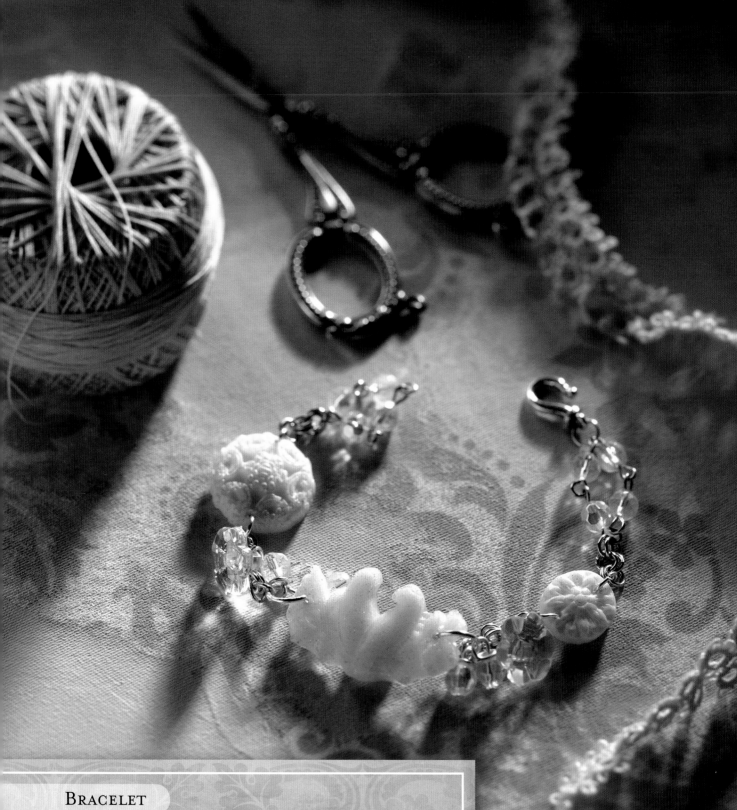

REMEMBERING

The horse-drawn coach came to

a halt. The time to depart the journey and begin the adventure was here. It was hard for her to fathom that she was actually sitting in the center of Boston where she would pursue her dream of becoming a physician, something surely not done or approved of by proper British society. But this was America, where all dreams could be pursued and even accomplished. Following in her fellow Briton's footsteps, she would take the journey to become a physician even if it meant being surrounded by men who would surely frown upon her.

Collecting her bags from the coachman, she felt her treasured bracelet shift beneath her glove. Memories hit her: the day her grandmother placed the treasure within her hands was suddenly playing in her mind; moments spent looking through her button basket while her grandmother and the other ladies embroidered and stitched, chatting about the local gossip.

It was the times when she was alone with her grandmother that she realized that there was so much more to her than what society saw. There was the healer and the caregiver, the protector and the heroine. Always the one to tell her to pursue her dreams; follow the path she wanted—not the path that society told her to follow.

Here she was on this, her first day in America, pursuing her deepest dream, the one that would forever change her life.

Materials

- Resin reticule (see page 8)
- Molding reticule (see page 10)
- Jeweler's reticule (see page 11)
- Hammering reticule (see page 13)
- Aging reticule (see page 20)
- Four 3mm iridescent faceted round crystals
- Two crystal flower buttons
- 3mm iridescent rosary chain
- Silver chain
- Seven 3mm jump rings
- Two 5mm jump rings
- Four 20-gauge silver headpins
- Silver clasp
- Crème oil paint
- Diamond dust glitter
- Drill with ¹⁄₁₆" (1.6mm) bit
- Metal stamping of birds
- One each of small, medium and large vintage-style buttons
- Packing tape
- Scrap wood
- White oil paint

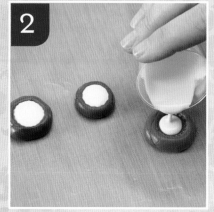

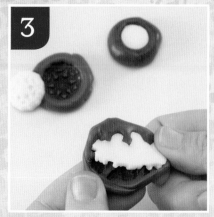

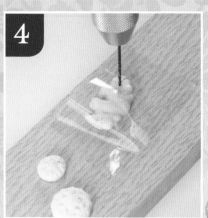

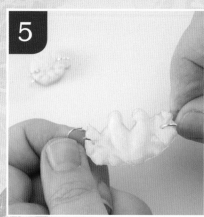

1 Prepare your work surface and create a resin mold with two-part mold putty (see Working With Two-Part Putty on page 10). Press the metal stamping into the mold and let it dry. Remove the stamping after 20 minutes. Prepare more two-part mold putty and make molds of the three buttons.

2 Mix 2 oz. (60mL) of resin and place into two measuring cups. Into one measuring cup add a drop of white oil paint and approximately ¼ teaspoon of diamond dust glitter (see Mixing Resin on page 8 and Adding Color and Inclusions to Resin on page 8).

Into the other resin cup, add a scant amount of crème oil paint.

Fill the molds, using the white and glitter resin and the crème resin in the desired molds. Let the resin cure for 24 hours.

3 After the components have dried, remove them from the molds.

4 Using the drill fitted with a ¹⁄₁₆" (1.6mm) drill bit, create a hole on each side of the bird stamping as well as each side of the buttons (see Drilling Into Resin on page 9).

5 Attach one 3mm jump ring into each of the holes of the buttons (see instructions for making jump rings on pages 11–12). In the holes of the bird centerpiece place one 5mm jump ring (see Opening and Closing Jump Rings on page 12). Don't close these jump rings.

6 To the jump rings on both sides of the centerpiece, attach a ½" (1.5cm) piece of silver chain.

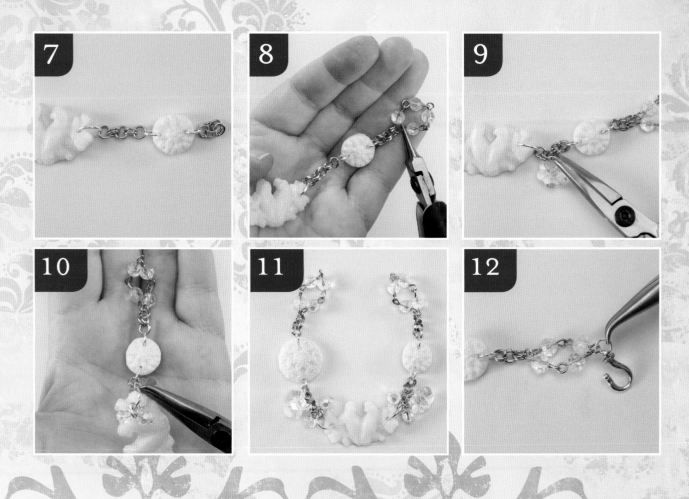

7 To each end of the silver chain, attach one button using the attached jump ring.

8 To the ½" (1.5cm) of chain, attach 2" (5cm) of the 3mm iridescent rosary chain (see Making Rosary Chain on page 15). Fold the chain in half and attach the last link to the first link of rosary chain.

9 To the chain between the centerpiece and buttons (on each side), attach one crystal button using a 3mm jump ring.

10 Create four dangles using four 20-gauge silver head pins and 3mm iridescent round faceted crystals (see Making a Wrapped Dangle on page 16). Attach two dangles to the jump ring on the bird charm.

11 Repeat steps 6–10 on the other side of the bird charm.

12 To one side of the bracelet, attach the silver clasp. To the opposite side attach one 3mm jump ring.

BRACELET

Dream from
THE SEA

The waves of the sea hit the shore

with an amazing force. The force was so great that there were many that viewed it as almost violent and unsettling, while others, like she, found it calming and magnificent all at the same time.

Opening the journal that lay in her lap, she pondered the words to place on the page. What was it that she felt like writing about today? Buried treasure at the ocean's floor, or perhaps mermaids that called to the sea voyager from the deep? These ideas whispered in her ear. However, there was a stronger voice today, one that came from the sea itself. The voice called out to her to explore the sands that lay under her kid-sole slippers.

Looking from the blank page of her journal to the chaise where her elderly chaperone sat, she sighed, knowing any adventure would have to take place while her dear aunt slept—no proper young lady walked along the shore scouring the sand for treasures that had no worth to others. It was only when she saw the watchful eyes of her companion fall that she dared rise quietly from her chair.

Using the hem of her walking dress to hide her feet, she removed her slippers. Moving slowly toward the shore, she relished the feel of the sand under her toes. The wind whipped at her bonnet, encouraging her coiffed locks to spring from the protection of the thin cloth and straw.

Bending to her knees, she searched for a hint of inspiration. It did not take long to find the treasure cocooned in the cool sand. Pieces of glass winked at her as the sunlight hit them. Her divine imagination painted a picture composed of pearls and stones intertwined with fine silver and ribbons.

Inspiration found, she hurried with a delicate step back to her chaise. Placing her feet into her slippers once more, she took up her pen and journal and began to weave a magical tale, one she would call "Dream from the Sea."

MATERIALS

- Resin reticule (see page 8)
- Jeweler's reticule (see page 11)
- Clasp reticule (see page 14)
- Aging reticule (see page 20)
- Firing reticule (see page 24)
- Six 3 mm round light blue beads
- Four 5 mm coin shaped pearls
- Three 10 mm oval center drilled light blue stones
- Two 7mm light blue potato pearls
- Two 5 mm Dark Blue Crystals
- Two 1mm dark-blue pearls

- Two 1 mm round dark blue pearl
- Two 1mm round pale blue beads
- One 15 mm turquoise briolette
- One 10mm turquoise briolette
- 3½" (9cm) length of commercial silver chain
- Five 9mm jump rings
- Nine 24-gauge head pins
- 18-gauge sterling silver wire
- 24-gauge sterling silver wire
- 19-strand silver beading wire
- Ring from an ornate toggle clasp set

- Two No. 1 crimp beads
- Three scraps of white tulle
- Light blue ribbon
- Blue seam binding
- 600-grit sandpaper
- Blue food coloring
- Crimping tool
- Drill with ¹⁄₁₆" (1.6mm) drill bit
- Mold release
- Seven flat rocks that resemble beach glass in varying shapes
- Two-part mold putty

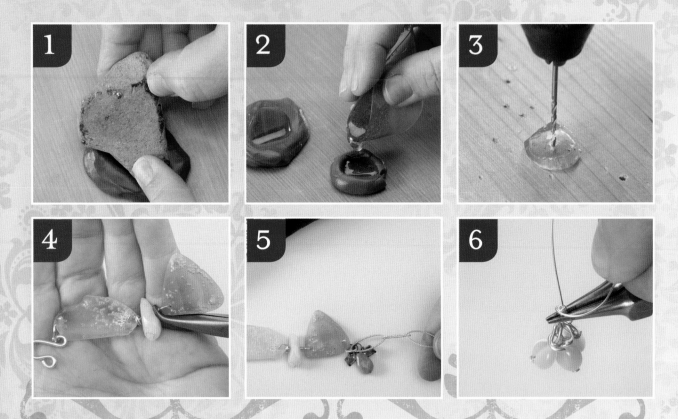

1. Spray the seven rocks with mold release and allow it to dry according to the manufacturer's directions. Prepare your work surface and mix enough two-part mold putty to make molds of the seven rocks (see Working With Two-Part Putty on page 10). Use the putty to cover the seven flat rocks, smoothing and shaping the putty as needed. Set aside to dry.

2. Mix the resin in one batch, approximately 1 oz. (30mL) total (see Mixing Resin on page 8). Separate the mix into three cups, adding blue food coloring to two of the cups until you achieve the desired shades: one a light blue and the other a darker blue. The last cup of resin will remain clear. Mix all the resin vigorously to create air bubbles.

 Pour the resin into the rock molds until you have two round light blue, one round dark blue, one large dark blue, one large light blue and one very small light blue. Pour two clear rocks. Let the resin cure for 24 hours.

3. Remove the resin faux glass from the molds. Using the drill with the 1⁄16" (1.6mm) drill bit, drill the resin beads in the following places: Drill two sides of both the opaque and dark blue faux glass; drill three holes at each corner of the light blue faux glass. Drill into the center of the three round pieces (see Drilling Into Resin on page 9).

Using the sandpaper, sand all the edges as well as the top and the bottom of the faux glass to create the look of beach glass.

4. Make a clasp from a 3⁄4" (2cm) piece of 18-gauge sterling silver wire (see Making a Simple Hook Clasp on page 14). Attach the clasp the end of a large clear faux glass piece using a jump ring (see Opening and Closing Jump Rings on page 12).

 Create a wrapped link using the 24-gauge sterling silver wire and a 10mm light blue oval stone. When you begin wrapping, attach the link to the clear faux glass piece; when you finish, attach the link to one of the drilled holes in the dark blue faux glass triangle.

5. Add a jump ring to one of the holes of the dark blue faux glass. To the jump ring, attach 3½" (9cm) of silver chain. Create three dangles using the head pins and 10mm turquoise briolette and two 5mm dark blue crystals, and attach them to the jump ring.

6. Make six dangles from the 1mm round pale blue beads and the 24-gauge sterling silver wire. Cut a 4" (10cm) piece of the 24-gauge wire and bend a loop 1½" (4cm) from the top. Add the three dangles to the loop and then wrap the remaining wire around the loop, closing the link. Do not trim the wire.

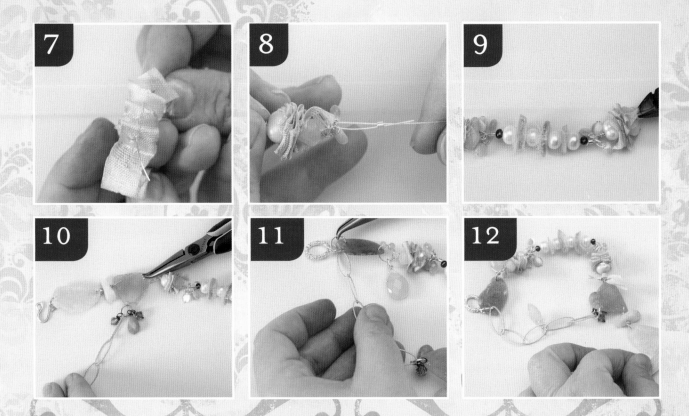

7 Onto the remaining wire from the dangle, slide on a 10mm oval light blue stone. Push the end of the wire through a 3" (7.5cm) piece of blue seam binding, gathering it accordion-style as you place it on the wire.

8 Slide on a 7mm light blue potato pearl. Finish the wire-wrapped loop. Make two ribbon stacks total.

Through the loop of the ribbon stack (dangle end), thread a 4" (10cm) strand of 19-strand beading wire. Slip a crimp bead on and thread the remaining stringing wire through it; crimp the bead (see Using Crimp Tubes on page 14).

9 String the following onto the stringing wire: 1mm dark blue pearl, 5mm pearl, round faux glass, scrap of tulle, coin-shaped pearl, tulle, faux glass, coin-shaped pearl, faux glass, coin-shaped pearl, dark blue pearl, 3 light blue dangles, 7mm light blue potato pearl, ribbon stack. Use a crimp bead to attach the ribbon stack, and trim the excess stringing wire.

10 Attach the beaded chain created in step 9 to the dark blue faux glass using a jump ring.

11 To the adjacent end of the strung pearls place three round light blue beads onto a jump ring. Attach the jump ring to the dark blue faux glass. Attach one 15 mm turquoise briolette to the other large piece of blue faux glass.

To the jump ring at the end of the dark blue faux glass, attach the decorative ring (this will be the closure for the clasp).

12 Add ribbon where desired, tying it into knots and trim the excess. Lay your piece flat on a table to see if all the jump rings are securely closed, and correct as needed

Tip A wonderful visual trick is to tie ribbon over the crimp beads to hide the hardware.

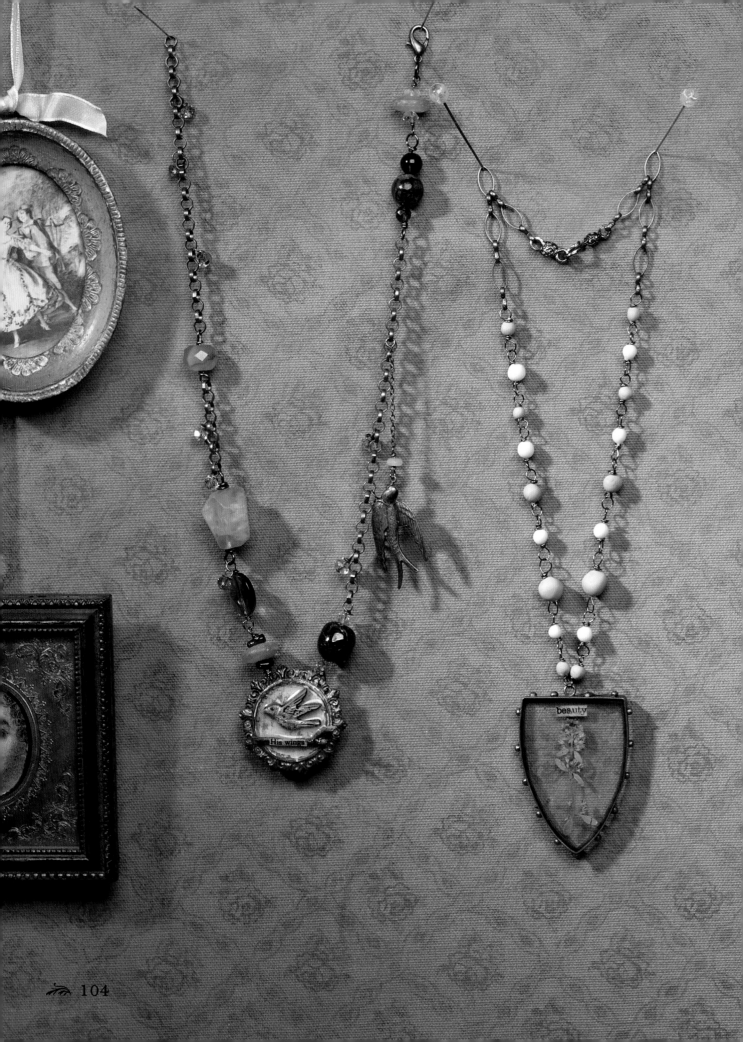

Being Creative With Resin and Resin Clay

While I fear our journey is coming to a close with the commencement of this chapter, I celebrate all we have learned and the tales of adornment told thus far. No journey with resin would be complete without the marrying of textures. A bit of resin clay seems simple and quiet until a bit of altering and manipulating takes place.

There are some things in life that reach out to us, tell us their own tales without even speaking and offer strength without us realizing it. While we might find great joy in seeing these things amongst our treasures, there is an even greater joy in adorning ourselves with them.

Items emerging from resin are simply that. The tales within this section talk of baubles that allow us to take flight in our thoughts and treasures that perhaps offer strength in moments when we are our least confident. Strong objects that refuse to be tamed when placed in resin is the focus. Composition, embroidery, paint, clay, a wee bit of painting, and of course altering are all topics we will cover with the next chapter. Vintage chain, resin beads and mold making are employed to create the conclusion of our adornments.

Prepare your work space and bring along a reticule or two. For it is now that we will learn the conclusion that our collection of tales holds.

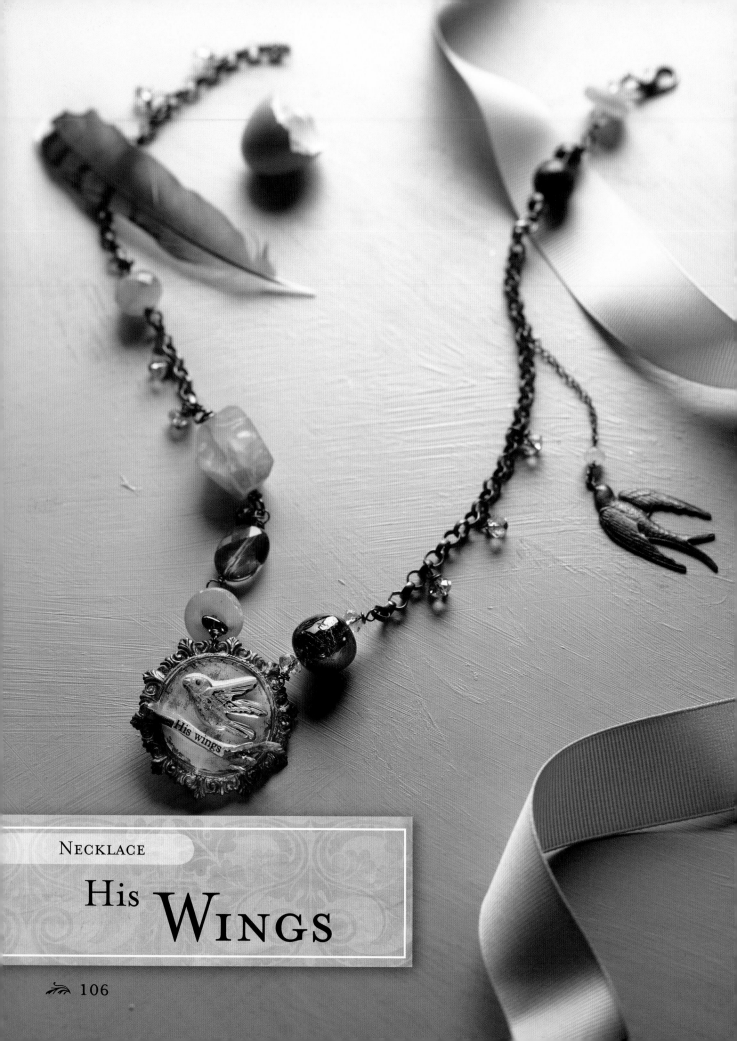

NECKLACE

His WINGS

"Father! Father, look!

There he is, flitting about in the sky again. What is he looking for, I wonder. He is dancing about as if he has no place to be. Perhaps he is playing."

Watching his young son run across the hill, reticule in hand and full focus directed on the small bird, he could not help but laugh out loud. Interest in birds was not something he had ever considered an amusing past time; however, in recent days he had found himself as enthralled as his eight-year-old son.

Until recent days he had never paused long enough to look up into the blue sky. Upon his son's insistence he had pulled the dusty books about birds from their shelves and began researching with the wee lad by his side.

Something magical did occur when a bird took flight—magical and, frankly, quite amazing. One could not help but watch with interest and wonder as the bird rose from its perch and danced with the breeze, not always leading the dance, but dancing all the same.

There was something to be said for leaving his law books and parliamentary documents aside for a day in the park watching the birds soar about on their delicate wings, or as his son would say, "dance upon the deep blue of the summer sky."

MATERIALS

- Resin reticule (see page 8)
- Jeweler's reticule (see page 11)
- Six 3mm Golden Shadow Crystals (Swarovski)
- Three 3mm Crystal Moonlight Crystals (Swarovski)
- Two 2mm faceted peridot beads
- Two 1.5cm center-drilled peridot beads
- Two pebble garnets
- One 14mm 10mm faceted green quartz nugget bead
- One 10mm center-drilled oval faceted lemon quartz bead
- One 8mm round peridot bead
- One 5mm round smoky quartz bead
- One 3mm faceted smoky quartz bead
- One 1.5cm faceted smoky topaz bead
- One 1cm round garnet
- 1½" (4mm) brass bird
- Small acrylic bird
- 3mm bronze chain
- 1mm bronze chain
- One 5mm bronze jump ring
- One 3mm bronze jump ring
- Nine 22-gauge gunmetal headpins
- 22-gauge gunmetal wire
- 1½" round metal stamping Bronze lobster claw clasp
- Twig
- "His Wings" printed onto ledger paper
- Scrap sheet music
- Acrylic paint in crème, burnt umber, red and black
- Drill with a ⅛" (1.6mm) drill bit
- Glue stick
- Gold pen
- Paper towel
- Scrap piece of wood
- Small paintbrush

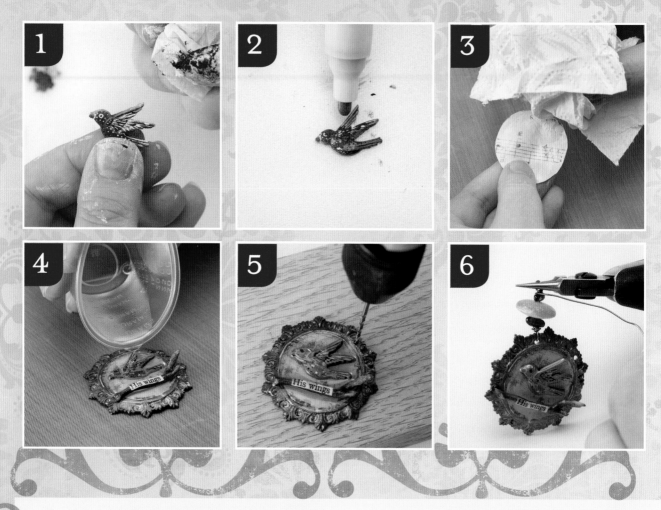

1. Using a small paintbrush, apply a layer of red paint to the acrylic bird. Let dry for five minutes and wipe off the excess with the paper towel. Repeat this step with the black and burnt umber paints.

2. Allow the paints to fully dry. Embellish the bird with a few specks of gold with the gold paint pen. Allow the bird to dry.

3. Cut a scrap of sheet music to fit into the bezel. Using the crème acrylic paint and a dry paintbrush, paint the paper and wipe off the excess paint with a paper towel. Let the paint dry.

4. Glue the paper and then the bird into the bezel (see Placing Imagery or Objects on page 9). Toward the bottom of the bezel, glue a small twig, and to the twig glue a scrap of ledger paper printed with the words "His Wings." Prepare your work surface. Mix ¼ ounce of two-part resin and pour into the bezel, being sure not to overfill and making sure there are areas of the stick that protrude from the resin (see Mixing Resin on page 8). Let the resin cure for 24 hours.

5. Place the bezel on a scrap piece of wood. Using the drill fitted with the ¹⁄₁₆" (1.6mm) drill bit, drill two holes at the top of the bezel 1" (2.5cm) apart from each other.

6. Begin working on the left side of the bezel. Using a 3" (8cm) piece of 22-gauge gunmetal wire, create a wire-wrapped loop link using a pebble garnet, a 1.5cm center-drilled peridot bead and another pebble garnet. Place the first loop through the left hole of the bezel before you close the loop (see Making a Wrapped Link on page 17).

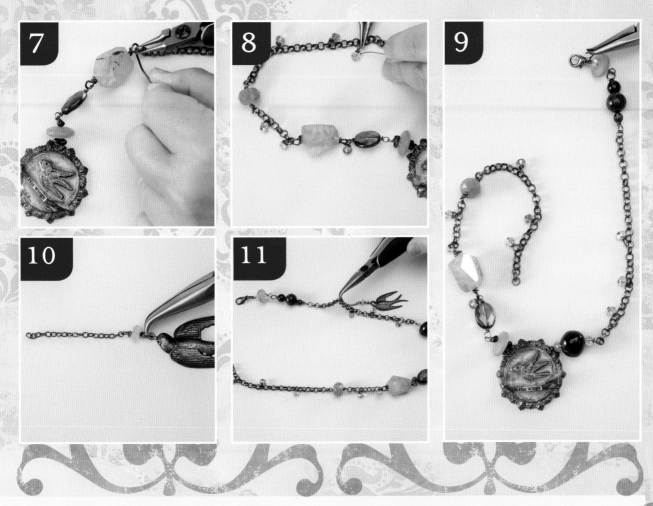

7 Using the 22-gauge gunmetal wire, add the following individual wire-wrapped loop links to the pebble garnet-peridot link: 1.5cm faceted smoky topaz bead, and one 14mm × 10mm faceted green quartz nugget bead. Before closing the final loop, add a 1½" (4cm) length of 3mm bronze chain.

8 To the end of the 1½" (4cm) length of chain, add a wrapped link using the 10mm faceted lemon quartz bead. Before closing the final loop, add a 4½" (11cm) length of 3mm bronze chain and place through the open loop of the lemon quartz link.

Using six 22-gauge gunmetal headpins and six golden shadow crystals, make dangles, attach the dangle 1" (2.5cm) apart, starting with the one attached to the top loop of the green quartz link (see Making a Wrapped Dangle on page 16).

9 To the right side of the pendant, create the remaining portion of the neck chain using the following wrapped links and sections of chain:

Wire-wrapped link with one 3mm Crystal Moonlight Crystal, one 1cm round garnet and one 3mm Crystal Moonlight Crystal; 5½" (14cm)

of 3mm bronze chain; a wrapped link with one 3mm faceted smoky quartz bead, one 8mm round peridot bead and one 5mm round smoky quartz bead; a final wire-wrapped link with one 3mm Crystal Moonlight Crystal, one 1.5cm center-drilled peridot bead and one 2mm faceted peridot bead.

To the end of last wrapped link, attach the bronze lobster claw clasp using the 5mm bronze jump ring (see Opening and Closing Jump Rings on page 12).

Using the remaining headpins, add three Golden Shadow Crystal dangles to the chain portion.

10 To the bird charm, attach a wrapped link using the 22-gauge gunmetal wire and the 2mm faceted peridot bead. Before closing the final loop, thread on a 1½" (4cm) length of 1mm bronze chain.

11 Open one 3mm bronze jump ring and attach to the bronze chain ½" (1.5cm) down from the peridot and smoky topaz link. With the jump ring open, attach 1½" (4cm) of 3mm bronze chain.

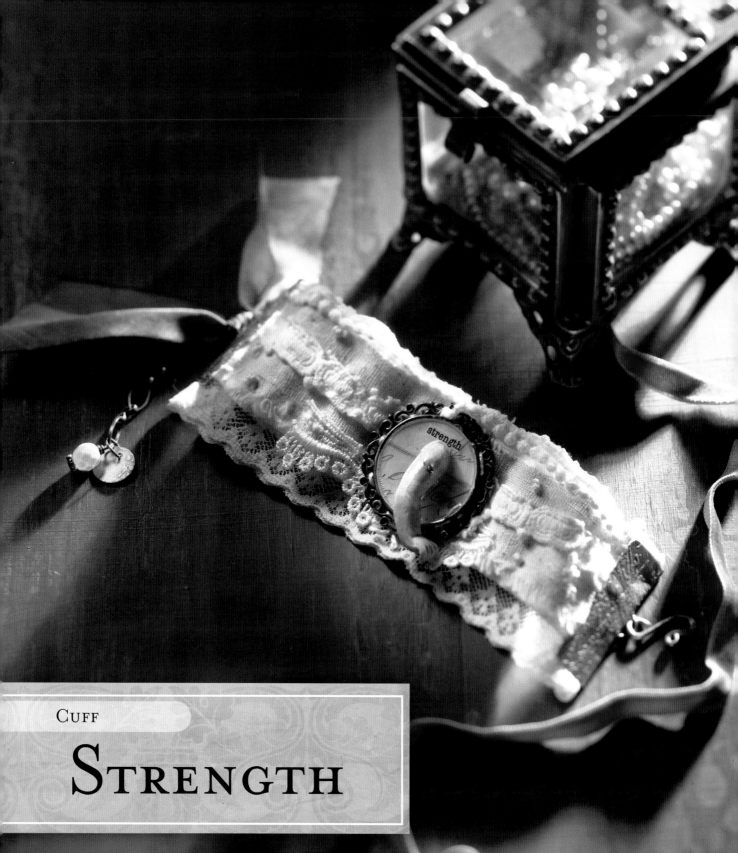

CUFF

STRENGTH

Another bolt of lightning crashed

through the dark sky, followed by a roll of thunder. She jumped from the small chair in her cramped cabin. She was struggling to stay calm—this day had been full of treacherous weather, creating an excess of trepidation.

Nothing for this journey had gone as planned. The ship she boarded for her trip to paradise had been little more than a bucket of boards held together by rusted nails, and pushed along by tattered sails. The crew had been cordial but soon proved inept when dealing with a woman, especially one determined to travel on her own. Independence was not a trait they expected or respected.

Determined to rid herself of the fear that lay within her, she rose from the chair and made her way to the deck where orders were being shouted and warnings issued. The floating vessel was losing the battle with Mother Nature. The captain spotted her, barking at her to get below. Stubborn as always, she approached him, offering any help she could. This time he ordered her to go below. She glimpsed the determination in his eyes: He would no sooner oblige the matriarch of the storm than her. Steadying herself as best she could, she grabbed at railings and rope, making her way back to the stairs leading to her cabin below.

Inside her miniscule room, she pulled the small box of her treasures from her valise; opening the case, she pulled the cuff from its resting place. Placing it on her wrist, she felt confident that the vessel, captain and crew would find the strength they needed to forge the storm.

Hours later, a bright light filtered through the small window in her cabin, the sun once again appearing. They had made it, battered and injured, but intact.

MATERIALS

- Resin reticule (see page 8)
- Jeweler's reticule (see page 11)
- Hammering reticule (see page 13)
- Clasp reticule (see page 14)
- Aging reticule (see page 20)
- Etching reticule (see page 22)
- Dyeing reticule (see page 25)
- 5mm faceted pearl bead
- 5mm silver charm
- Silver bead spacer

- 2½" (6cm) silver chain
- Two 5mm silver jump rings
- 22-gauge headpin
- 26-gauge silver nickel wire
- 22-gauge silver wire
- 18-gauge silver wire
- 3.5cm silver filigree bezel
- Antique bisque doll arm
- Antique ledger paper
- Crème thread
- Silk ribbon

- Lace trim
- Taupe linen
- Muslin
- Natural batting
- Lace scraps from appliqué
- 2" (5cm)-wide lace ribbon
- Drill with ¹⁄₁₆" (1.6mm) bit
- Embroidery needle
- Fabric glue
- Straight pins

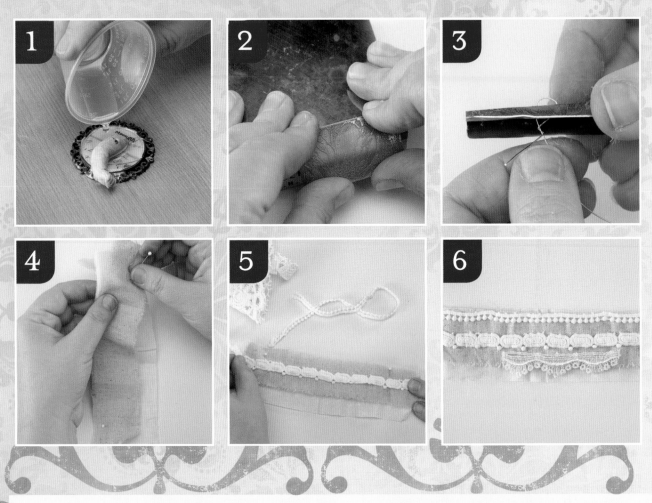

1. Cut a piece of antique ledger paper to fit the bezel (see Placing Imagery or Objects on page 9). To the center top of the bezel, add the word "Strength" that has been printed on the ledger paper.

 Prepare your work surface. Mix ¼ ounce of two-part resin and pour it into the bezel, being sure not to overfill (see Mixing Resin on page 8). Place the bisque doll arm into the resin, making sure the resin does not spill out of the bezel.

2. Cut two pieces of 26-gauge silver nickel wire measuring 1¾" × 1" (4.5 ×2.5cm). Stamp the metal with the desired design and etch the metal (see Etching Metal on page 22). Etch the 5mm silver charm at the same time; set it aside for later.

 On the edge of a bench block or sturdy table, bend the silver nickel bars.

3. Find the center of the metal bar and drill two holes. Repeat this step on the second metal bar.

 Use your fingers to bend the bar more (if needed, use the bench block again). Cut a 2" (5cm) piece of 22-gauge silver wire and run it through the drilled holes. Wrap and close the wire on the inside of the bar. Repeat this with the other bar.

4. Cut a piece of muslin measuring 7" × 2" (18cm × 5cm). On top of the muslin, layer a piece of natural batting measuring 6" × 1" (15cm × 2.5cm). Cut a piece of taupe linen measuring 7" × 1½" (18cm × 4cm). Pin the pieces together to hold them in place.

5. Cut a piece of lace trim the length of the fabric stack and tack it down to the linen fabric with fabric glue. To the center of the cuff, place a wider piece of trim, again tacking it down with fabric glue.

6. Adhere a strip of lace to the center of the fabric stack.

- -

Tip Use the glue sparingly if you are going to put your cuff into a sewing machine, as the glue can gum up the needle and feeder.

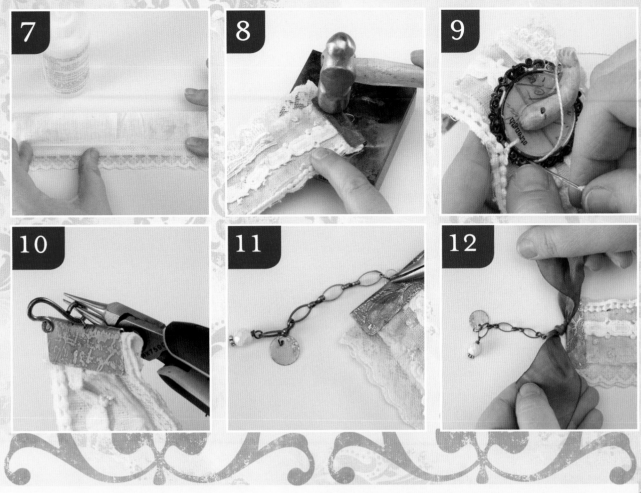

7 Along the length of the back, adhere a piece of 2" (5cm) wide lace ribbon, folded in half.

8 Fold both ends of the fabric cuff approximately ¼" (6.5mm). If needed, use a drop of glue to hold the folds in place.

 Place a folded fabric end into the opening of a metal bar. Use a little bit of glue to help secure the metal and the fabric. Use the hammer and block to hammer the bars into place. Repeat on the other side of the cuff.

9 Using the embroidery needle and crème thread, stitch the bezel to the cuff. After the bezel is secured, add French knots to the piece in a random fashion. Using the embroidery needle and crème thread, add random stitching to the cuff such as French knots and straight stitches.

10 Cut a 2" (5cm) piece of 18-gauge silver wire and create a clasp (see Making a Simple Hook Clasp on page 14) and age it (see Patina Metal on page 20). Attach the clasp to the wire loop on the metal bar on the right side of the cuff.

11 Cut a 2½" (6cm) piece of the silver chain. Attach the etched charm to the end of the chain using a 5mm jump ring (see Opening and Closing Jump Rings on page 12). Create a dangle using the 22-gauge headpin and a silver bead spacer and 5mm faceted pearl bead (see Making a Wrapped Dangle on page 16), threading the wire through the end of the chain before wrapping the loop. Using a 5mm jump ring, attach the chain to the loop on the left side of the cuff.

12 Tie a piece of dyed brown silk ribbon to the top of the chain (see Dyeing Ribbon on page 25).

 Tip In lieu of embroidering in step 9, machine stitching will also work on this piece. You will have to use the sewing machine at the end of step 7, to avoid damaging your machine, the metal bars and the resin bezel.

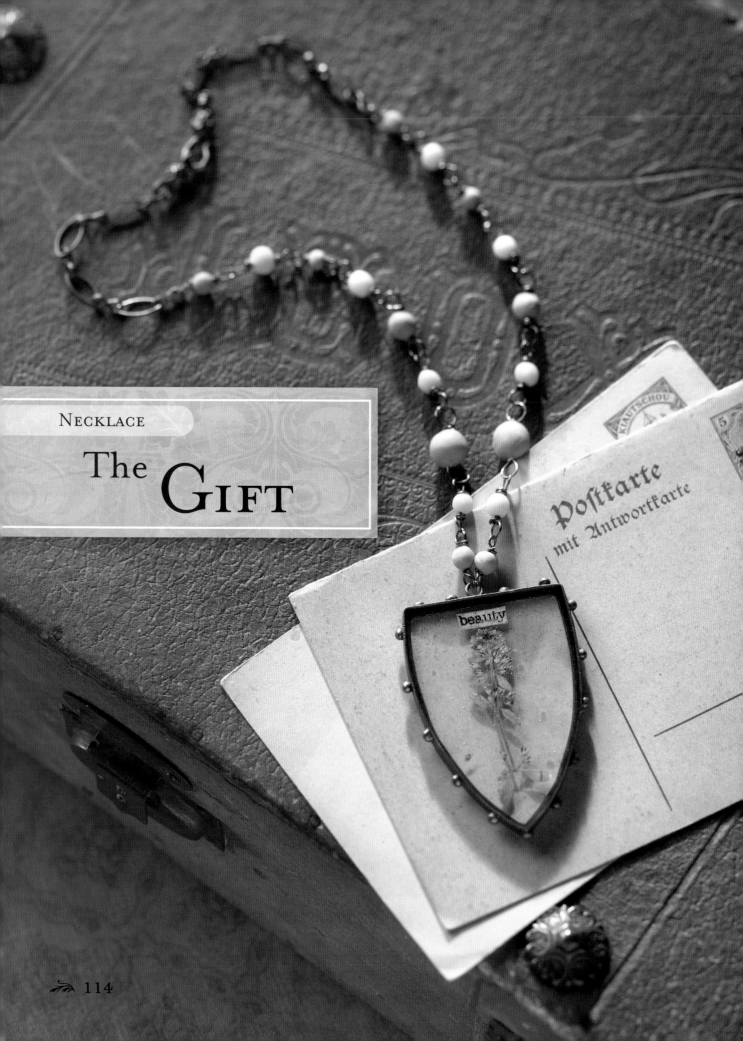

The GIFT

Her booted foot tapped the

floor as she peered out the window of the train. Her heartbeat kept time with the chugging of the locomotive as they made their way down the tracks closer to their destination, the destination she had dreamt of for a lifetime. It was unfathomable to her that she was truly on the adventure her mother had spoken of so many times. Looking about the private car that served as the gathering place for their small group, she pondered the conversations they had had. All were full of hope that "the gift" would be located on this dig.

Pulling her journal from her bag, her mother's letter fell into her lap. The letter spoke of adventure and pilfered sites, but it also spoke of hope. Just thinking about what lay ahead filled her with amazement. Lifting her pen, she wrote in her journal:

Today we boarded the train that will take us to our final destination. We are so far from home now, away from everything and everyone. I cannot help but wish that Father and the wee ones were here to share this adventure. I find I am overwhelmed with excitement and anticipation. I cannot wait to arrive at our final stopping place, the gateway to the desert. I have dreamt about "the gift" every night since we left—I feel as though it is speaking to me, calling to me. Silly, I know, but I hear it all the same. Last night's dreams started as the others: I was standing in the middle of the pyramid, and when I looked down into the golden sand I saw it gleaming at me. Instantly I was transported to the ballroom where all were commenting on the treasure that adorned my neck. For now, I count the rotations of the wheels and listen as the tracks under us shuttle us to the massive pyramids, and wonder if I believe in signs.

Sighing, she placed the journal back into her bag. Closing her eyes, she hoped for perhaps another sign.

MATERIALS

- Resin reticule (see page 8)
- Jeweler's reticule (see page 11)
- Gunmetal chain
- Two 3mm gunmetal jump rings
- 24-gauge gunmetal wire
- Hobnail triangle bezel
- Sprig of lavender
- "Beauty" printed on vintage paper
- Air dry resin clay
- Moss acrylic paint
- Brass clasp set
- Packing tape
- Straight pins
- Timer

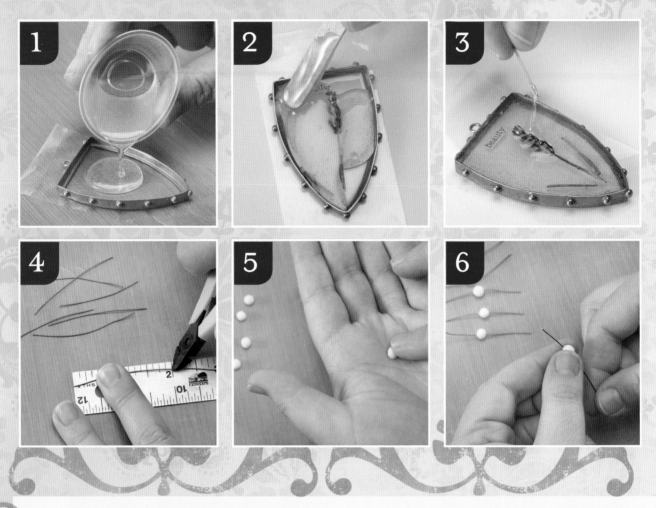

1. Back the Hobnail triangle bezel with packing tape. Mix the resin (see Mixing Resin on page 8) and pour it into the bezel until the piece is halfway full. Let it dry for 12 hours.

2. Lay a sprig of lavender and the word "beauty," which has been printed onto vintage paper, onto the first layer of resin. Mix another batch of resin and let it sit for 20 minutes; then mix it vigorously with a craft stick. Let the resin sit for an additional 15 minutes (checking every 5 minutes to ensure that it has not become solid). Mix the resin vigorously and pour it into the bezel, using the craft stick to help spread it around the bezel.

3. To ensure that the resin looks like old glass, you may need to insert a straight pin into the resin to make the bubbles sit deeper in the resin layer. Be gentle or the bubbles will pop.

4. Cut eight 1¾" (4.5cm) pieces of 24-gauge gunmetal wire. Cut ten 2" (5cm) pieces of 24-gauge gunmetal wire and set them aside for later.

5. Cover your work area with a nonstick craft sheet. From a block of resin clay, pull off a piece that is approximately 1" × 1" (2.5cm × 2.5cm). Pull small pieces from the larger piece and create eight 5mm beads.

6. Skewer the center of each bead with one piece of 1¾" (4.5cm) wire. After skewering all eight beads, place them onto a nonstick craft sheet to dry for 24 hours.

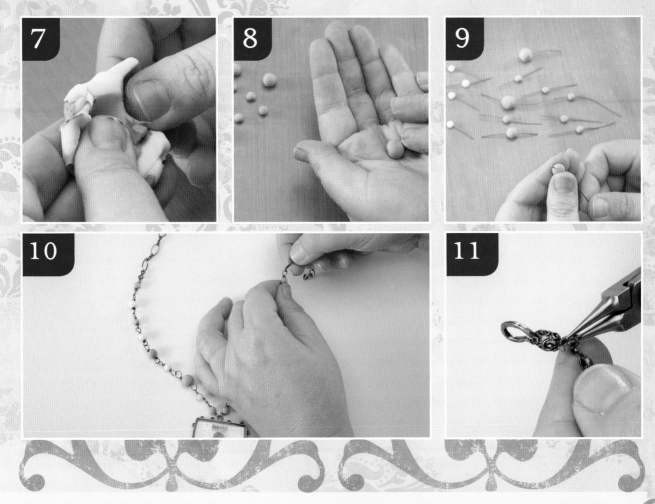

7. To make colored beads, take a 1½" × 1½" (4cm × 4cm) piece of resin clay and place a small drop of moss acrylic paint onto the top of the clay. Knead the paint into the clay as you would knead dough.

8. Roll the resin clay into a ball. Pull off ten pieces of clay and begin creating beads. You will need six beads measuring approximately 3mm, two beads measuring 5mm and two beads measuring approximately 8mm.

9. Through the center of each bead, place one piece of 2" (5cm) 24-gauge gunmetal wire. After all ten beads have wire through the centers, place them on the nonstick craft sheet to dry for 24 hours.

Tip If you find your hands sticking to the clay, place a small drop of water on the clay.

10. To make one side of the chain, create wrapped links from the clay bead and wire pieces, using the following order (attach the first bead t the top of the bezel): 3mm moss bead, opaque bead, 8mm moss bead, opaque bead, 5mm moss bead, opaque bead, 3mm moss bead, opaque bead, 3mm moss bead. Prior to closing the top moss bead, attach a 3" (8cm) strand of gunmetal chain.

 Repeat this step for the other side of the chain.

11. To the end of the chains, attach the brass clasp set using the 3mm jump rings.

Fly
SWEET ONE

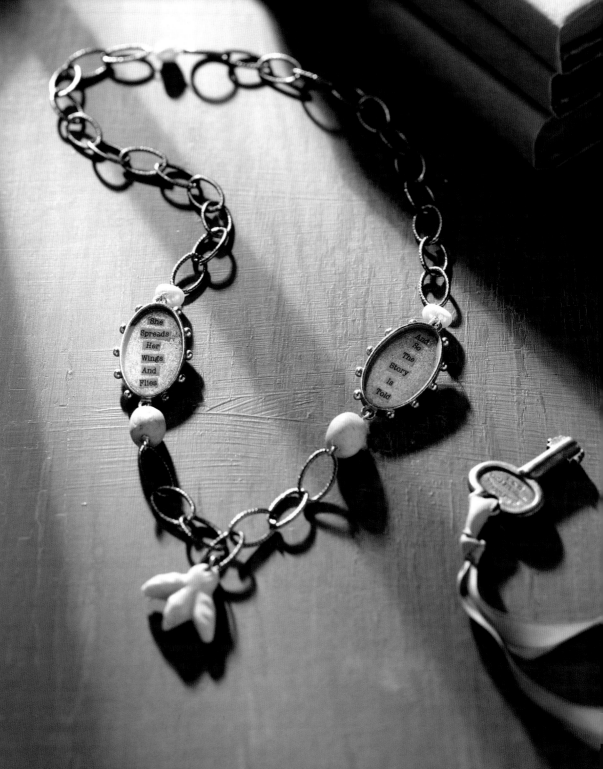

She Spreads Her Wings And Flies

And So The Story Is Told

She looked up when the clock

chimed and closed her book. She had spent the entire day going through her journals and books. Remembering those who had walked through her door relating their stories to her throughout the days of her life. The tales of realization and adventure had offered excitement, while tales of loss and found hope tugged at her soul.

With a heavy heart, she placed the last book in the box and closed the lid. Her valet would come later to pick up the last personal belongings that remained in the establishment. Pulling her pelisse about her shoulders, she turned and looked over the fabrics and lush colors, knowing that this chapter of her life was closed. Tomorrow her niece would enter the doors as the new modiste. A new adventure lay ahead for a new generation.

As the footman handed her into the waiting carriage, another hand met hers. One she knew as well as her own. He had come on this important day. Looking into his eyes, she saw understanding and caring—he above all knew how difficult closing this door was for her.

Settling her skirts about her, her hand still in his, she bent her head to his shoulder only to lift it again when he held out a box. Removing the lid, she drew in a breath. The amazing piece that stared back at her spoke volumes as to what the day meant "and so the story is told, she spreads her wings and flies." How true she thought, how true.

MATERIALS

- Resin reticule (see page 8)
- Molding reticule (see page 10)
- Jeweler's reticule (see page 11)
- Aging reticule (see page 20)
- One 5mm aged jump ring
- Three 3mm potato pearls
- Silver chain

- Silver chain
- 24-gauge silver wire
- Two silver oval hobnail bezels
- Printed text on vintage ledger paper
- Bisque bird
- Air-dry resin clay
- Craft knife

- File or 1/16" (1.6mm) dowel
- Glue stick
- Grey pencil
- Microplane grater
- Titanium buff oil paint
- Water (optional)

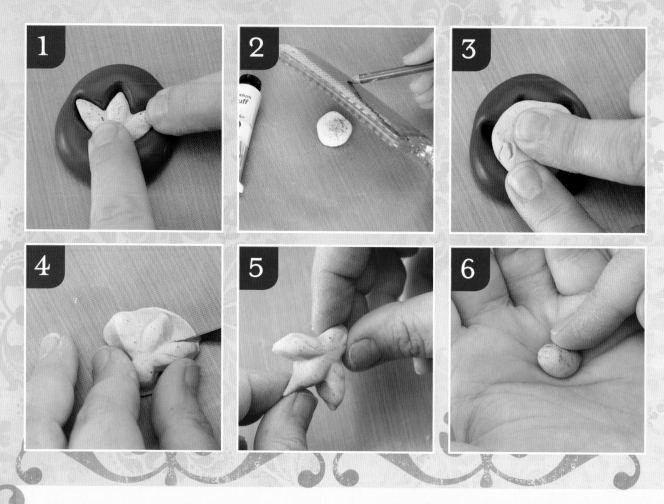

1 Using the two-part mold putty, create a mold of the found bisque bird (see Working With Two-Part Putty on page 10). Let the mold dry and remove the bisque bird.

2 Prepare the work surface with a nonstick craft sheet. Pull off a piece of resin clay approximately 3" × 3" (8cm × 8cm) and press it flat onto your work surface. Place a drop of titanium buff oil paint on the clay. Using a microplane grater, grate pieces of grey pencil into the paint.

3 Knead the clay gently until the paint and pencil bits are thoroughly mixed. If the clay becomes too dry, place a drop of water on your hands and continue kneading.

 Pull off a 1" × 1" (2.5cm × 2.5cm) piece of the colored clay and roll it into a ball. Press the clay into the silicone mold created in step 1.

4 Gently remove the clay from the mold. Using a craft knife, trim the excess clay and clean up the edges.

5 Using your fingers, gently pull one end of the clay to form a more defined beak.

6 Divide the remaining clay into two equal amounts. Using the palms of your hands, roll the clay pieces into two small balls. After the balls have formed, shape the top of the balls until they resemble eggs.

Tip When shaping eggs, any lines that appear in the clay should be left because they enhance the natural look of the egg.

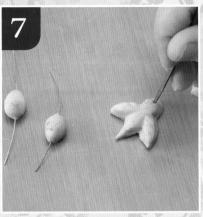

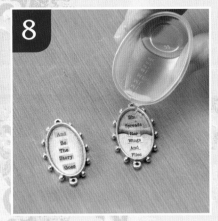

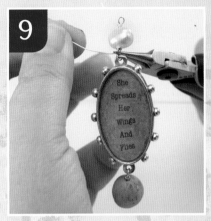

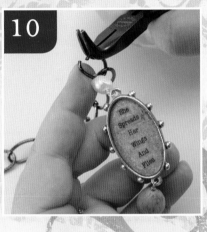

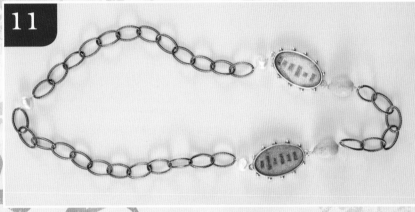

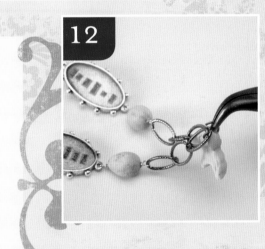

7 Cut two 3" (8cm) pieces of 24-gauge silver wire and insert one wire through the center of each egg. Using the end of the file or small dowel approximately ¹⁄₁₆" (1.6mm), poke a hole into the tail of the bird charm. Set the pieces on the nonstick craft sheet and let them dry.

8 Into two bezels, use the glue stick to adhere the words "And so the story is told. She spreads her wings and flies" (see Placing Imagery or Objects on page 9). Mix and pour the resin into the bezels (see Mixing Resin on page 8). Let it dry for 24 hours.

9 Using one of the eggs, make a wrapped link and connect it to the bottom of a bezel (see Making a Wrapped Link on page 17).

 Using a 3" (8cm) piece of 24-gauge silver wire and one 3mm potato pearl, make a wrapped link at the top of the bezel.

 Repeat this step for the remaining bezel.

10 Using chain-nose pliers, attach an 8½" (21.5cm) length of silver chain onto the pearl/bezel link. Find the center of the chain and disconnect the center two links. Make a wrapped-link using the remaining pearl and attach it to the two links to reconnect the chain.

11 Cut a 5" (13cm) piece of the silver chain and attach the chain to the egg links on the bottom of the bezels.

12 Find the center of the bottom chain and attach the bird charm using a 5mm jump ring (see Opening and Closing Jump Rings on page 12).

TOOLS AND MATERIALS

 Each creator has an amazing stash of baubles and bits. Thus the holder of tales must have a sufficient supply of ready materials and tools at hand, as one never knows when a tale must be told. While each project will call for specific beads and materials, this section will give you a comprehensive overview of what you will need to complete the projects in this book. Not all of the projects use all of the items listed, and some more common materials are left out of this section, so read through the Materials lists to discover what you'll need. Also, review the Reticules lists throughout the Techniques section to truly prepare yourself for your jewelry stories.

Acetone

Acetone is used to clean metal before etching.

Awl

An awl is used to create a starting point for drilling holes. It can also create a hold when a hammer is applied in a firm manner to the top.

Baking Soda

Sodium bicarbonate halts the etching process. Keep it in a plastic container with a lid.

Beads and Pearls

Beads come in an array of colors, shapes and sizes. Rounds, bicones and coins are some of the most widely available. You can find beads made from a variety of materials, including glass and natural elements, as well as semiprecious and precious stones.

Pearls, like beads, come in a variety of shapes, including potato pearls (oval in nature), coin (resembling a coin), and teardrop (which looks like a drop of water). Pearls that are half-drilled do not have a hole all the way through the center; they are intended primarily for rings and earrings. When buying pearls for the projects in this book, look for full-drilled or whole-drilled.

Beeswax

A block of beeswax is a must-have when sawing. The beeswax reduces the friction between the saw and the metal or Faux Bone, making it easier to move the saw while cutting.

Bench Block

A smooth block of metal meant to be used when hammering. These blocks come in a variety of sizes; in most cases, a small bench block is the right size for jewelry.

Bench Pin

A bench pin is used as a support for filing and sawing. There is a V-shaped opening where you place the item you need to saw or file, giving you a sturdy, open surface to work on when sawing. When clamped to a solid surface, the bench pin acts as an additional workspace.

Bezels

The most common type of bezel is created with metal and has an area into which resin can be easily poured. You can easily find bezels at local and online craft and jewelry retailers. Throughout this book, I also show you haw to make your own bezels.

Butane Torch

A butane torch is sufficient for the small projects included in this book. It can be used to manipulate Faux Bone and to fire wire for soldering and ball headpins.

Circle Punch/Disk Cutter

A circle punch or a disk cutter is a metal block composed of two layers with an open center that features various-sized round cutouts on the top and the bottom of the piece. The cutter generally comes with an array of punching dappers. This device allows you to easily cut perfect rounds from sheet metal.

Containers

Keep a variety of containers on hand, including glass and plastic; with and without lids. You'll want to reserve individual containers for dyeing, ferric chloride (glass with lid) and patinating.

Cordless Drill

A battery pack provides the power to this type of drill. This is the perfect drill for creating jump rings and twisted wire. I prefer a drill with the option of high and low speeds. Prior to using the drill to make jump rings, make sure the head of the drill opens wide enough to insert a $\frac{1}{2}$" (1.5cm) dowel or mandrel. Have a variety of drill bit sizes on hand; typically a $\frac{1}{16}$" (1.6mm) drill bit is used to drill through resin as it creates an even, small hole.

Craft Sheet

This is a nonstick sheet that will protect your work surface while offering a wonderful nonstick surface for your bezels and resin to rest upon as they dry. When the resin is dry, it peels right off the sheet. It is also a great surface to use when working with resin clay and when you want to protect your work area.

Craft Sticks

These flat wooden sticks can be found at any craft supply retailer. We use them throughout the book to mix resin, embellish resin and gently perfect resin pieces.

Crimp Tube

A crimp tube is a small tube that is placed on stringing wire. When closed over the wire, the tube secures the wire and closures.

Doming Block/Dapping Set

This is a cube of metal that is composed of circular, cuplike impressions. A disc of sheet metal is placed within the cup and a dapper and hammer are used to form bezel cups.

Dowels and Mandrels

A dowel is a round piece of wood that comes in various sizes; keep an array of sizes on hand. A mandrel is made from durable and sturdy steel. Both can be used to create clasps, jump rings and links. A knitting needle can be used in place of a dowel if needed. I prefer mandrels when making jump rings, but wooden dowels work just as well.

Dye

Dye comes in a grand variety of types and colors. I use dyes throughout the book to give ribbons and fabrics rich, worn looks. Read each dye label because not all dyes can be used on all fabric types. Keep in mind that the size of the bath will be determined by the amount of fabric you are dyeing.

Also, some dyes require you to prepare them on top of the stove. In all cases, whatever process is required, reserve any containers and pans you use for dyeing only.

Embroidery Needles

An array of sizes is not necessary, although it is good to keep three on hand at all times: #22 for general work; #28 for fine work; and a blunt tapestry needle for going through the holes drilled in resin.

Eyelets

Eyelets are metal tubes that are used to create sturdy holes in fabric. Eyelets often come in sets containing the two-part metal pieces and an eyelet tool. The manufacturer's instructions should be all you need to start using eyelets!

Ferric Chloride

Do not fear the name ferric chloride; though it is a strong chemical, it creates a beautifully etched surface when it is used properly. Always wear gloves when handling this product, even when the container is closed.

Files

A small set of files should be on hand, as you will need to smooth edges on straight and curved surfaces. Have a large jeweler's file available; you can find one through a supplier of metalsmith items or at a hardware store. Keep the file wrapped in a soft cloth when it's not in use to protect both the file and your other tools and materials.

Firing Brick and Pan

A firing brick is a simple block made of nonflammable materials found at craft and jewelry mercantile establishments. Place the firing brick inside a pan, like a square cake pan, for safety. I prefer pans that are made from sturdy, nonstick materials.

Flush Cutters and Wire Cutters

Buy the highest-quality pair of flush cutters you can afford. Flush cutters will leave the ends of cut wire smooth, reducing the possibility of discomfort from sharp wire. Wire cutters are a more all-purpose tool. I like to cut wire with wire cutters and then use the flush cutters to clean the wire ends.

Gloves

A sturdy pair of vinyl gloves is a necessity for protecting your hands from harsh chemicals while etching or patinating metal. They also are useful for keeping dye off your skin.

Hand Drill

A hand drill is simply that: a drill that is powered by cranking by hand. This is the preferred method of drilling through resin because it allows great control and will not crack the resin.

Hammers

Hammers can be used to flatten wire, smooth it out or make designs. A hammer that is short in stature needs to be within this assortment, as it is perfect for hammering stubborn bits of wire flat as well as adding marks and divots. Get a chasing hammer to help metal maintain a smooth surface. The opposite side of the chasing hammer, the ball-peen end, is perfect for creating divots in the metal. You can easily find hammers at craft retailers and hardware stores.

Heat Gun

A very powerful gun that pushes heat. Use the heat gun to accelerate the drying process of ink on metal as well as for manipulating Faux Bone.

Jeweler's Saw

Jeweler's saws come in two parts: the saw frame and the saw blades. The saw frame is used to house the saw blade; it is adjustable. Saw blades come in a variety of sizes, 2 is the blade I turn to the most often. When manipulating items such as Faux Bone, be aware that a different saw blade may be needed. Using a jeweler's saw instead of wire cutters to cut jump rings, creates a clean cut without the extra step of cleanup.

Measuring Cups

Use the little cups meant for the dispensing of medicine or small, clear plastic cups when measuring and mixing two-part resin. The cheaper these are, the better, because you can only use them once.

Metal Punch

When forced into metal using a hammer (and a bench block placed under the metal), metal punches leave an impression. A metal punch can be one punch or a set of punches. The most common set is the alphabet, but you can find decorative metal stamps through jewelry suppliers.

Molding Putty

A wonderful two-part putty that when kneaded together creates molding material. I like to make molds of my found objects and use the molds to create resin pieces; it preserves the one-of-a-kind items in my collections while allowing me to use them again and again.

Paper Towels and Soft Towels

Keep a supply of paper towels nearby for quick cleanup jobs. They are especially useful to clean up drips from dyes and patina solutions. Have a supply of soft towels available for polishing metal; it is important to use a soft towel so you do not create unwanted divots and marks on the surface of the metal.

Patina

There are many patinas available to alter your jewelry elements. Items such as liver of sulfur and other wonderful compositions are available for adding a bit of age to your tale; I prefer to use a liquid patina or liver of sulfur. Keep a small bowl with a lid that is dedicated to your patina solution of choice. Always follow the manufacturer's instructions and work in a well-ventilated area.

Pliers

Pliers are important tools to have on hand for any manner of jewelry making. Buy the best pliers you can afford. It is important to note that when working with fine silver, your tools should not have teeth in the openings or they will mar the metal. Here are the pliers used throughout the book.

CHAIN-NOSE PLIERS: These pliers are useful for a variety of jewelry techniques, including opening and closing jump rings, tucking in wire ends and wrapping wire. Some pliers have a curved point at the end; these are bent-nose pliers and are especially useful for working in tight spaces.

CRIMPING PLIERS: Crimping pliers are an essential tool for closing crimp tubes.

FLAT-NOSE PLIERS: A must-have for holding wire during firing. Purchase a pair of pliers with a protective coating over the handle as the flame from the torch will heat this area quickly.

ROUND NOSE PLIERS: Perhaps the most used pair of pliers in the projects from this book. They are used to turn loops, make rosary chain and help create hooks.

Rubber Stamps

Rubber stamps are available in virtually every image and pattern you can think of. Purchase stamps that are deeply etched to make the most of the etching technique and to embellish Faux Bone.

Scissors and Rotary Cutters

It is important to have a good pair of scissors in your creative cupboard for multipurpose tasks like trimming paper, lace and thread. Keep a few less-expensive pairs on hand for projects where the scissors may come in contact with resin or patinated items. Use a rotary cutter with a cutting mat for cutting fabric; add a ruler for beautifully straight lines.

Sanding Tools

Sanding tools allow you to quickly age your resin pieces or create a surface with tooth. I suggest having at least 800-grit sandpaper or block, and a filing block, typically used for manicures, in your toolbox.

Spoon

When dyeing trims and fabrics, I prefer to use a wooden spoon, set aside for dyeing purposes only. On occasion, I may use a plastic spoon if a wooden spoon is not readily available.

Steel Wool

Use steel wool to clean metal and wire after firing, for aging with patinas and etching, and to buff the metal at any time. Keep a good supply of this on hand.

Toothbrush

A soft toothbrush is the perfect implement to remove baking soda from metal during the etching process.

Tweezers

These tiny tips are capable of picking up the smallest crimp tube. It is a great idea to have two sets of tweezers: a plastic-coated set to remove items from chemical solutions; and a plain set for wire left in its original state.

Two-Part Resin

Two-part resins are the basis for all the projects you see in this book. When creating my tales, I use a jeweler's grade resin—pure in color, jeweler's grade resins cure to look like clear glass. I prefer ICE Resin for those very reasons. When

measuring your formula, it is equal parts unless otherwise noted on the manufacturer's label.

Ribbon

A variety of fabrics and styles are used to create ribbon. Silk and high-quality satin are the most pliable. To prevent fraying, cut ribbon on the diagonal.

Sheet Metal

Sheet metal is available in many different gauges as well as a variety of metals such as brass, copper, sterling silver and silver nickel. Remember: the lower the gauge, the thicker the metal is.

Silk Shantung

Silk shantung, also called dupioni silk, comes in a variety of colors, weights and qualities. When working with shantung, be aware that there are synthetic varieties that may not take dyes in the ways you would hope. In lieu of cutting the fabric, tearing is acceptable because it creates a straight line when done properly.

Solvent Ink

This type of ink is meant for non-porous surfaces. We will use this type of ink when etching metal. It needs sufficient time to dry, or you can use a heat gun to cut down the drying time. I prefer StazOn Ink.

Wire

Like sheet metal, wire is available in a variety of gauges and types of metal. The lower the gauge number, the wider and heavier the wire will be. Keep an array of gauges on hand to help you meet the needs of any jewelry project. Heavier gauges, 20–16, are good to use for clasps. You will also use wire to create your own ball headpins, but heavier gauges will be slower to form a ball.

RESOURCES

DOVER PUBLICATIONS
www.doverpublications.com
Copyright-free clip art

ICE RESIN
www.ICEResin.com

RANGER
www.rangerink.com
Craft sheets

VINTAGE RESOURCE DESIGNS
www.vintagedesignresource.com
Vintage and antique findings and chains

CRAFT AND JEWELRY STORES
Jewelry materials and supplies

FABRIC STORES
Fabric, trims and tulle

HARDWARE STORES
Mandrels and dowels

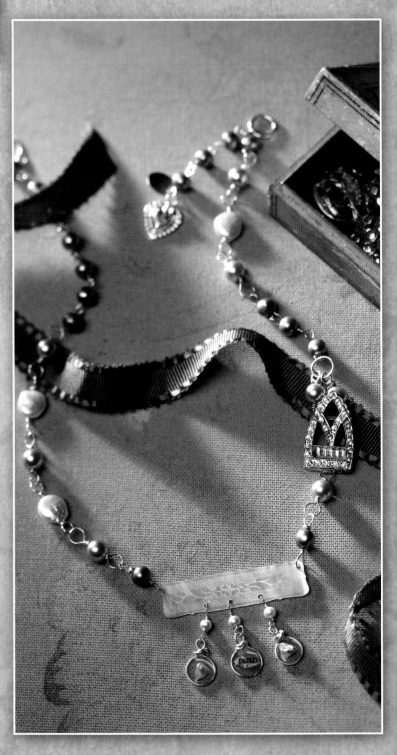

INDEX

acetone, 122
aging metal, 20
awl, 122

baking soda, 122
ball headpins, 24
beads, 117, 122
beeswax, 122
bench pin, 122
bezels, 9, 27, 122
birds, 98, 107, 120
book dangle, 64–69
bracelets
 Charming my Soul,
 28–31
 Dream from the Sea,
 100–103
 Remembering, 96–99
 Rendezvous With
 History, 38–41
 Today and Tomorrow,
 50–55
 Where Art Thou,
 82–85
button stampings, 98

cameo pin, 42–45
casting, 92
circle punch, 122
clamshells, 18, 19
clasps, 14
clay, 88, 117, 120
craft sheet, 123
craft sticks, 123
crimp tubes, 14, 123
cuffs
 Her Name is Grace,
 46–49
 Strength, 110–113
cutters, 123, 125

dangles, 13, 16
dapping set, 123
disk cutter, 122

doming block, 123
dowels, 123
drilling, 9, 122
drills
 cordless, 123
 hand, 124
 making jump rings
 with, 12
 for twisting wire, 21
dye, 123
dyeing fabric, 25, 125

embroidery needles, 123
etching, 22–23, 122, 125
eyelets, 123

Faux Bone, 66
faux glass, 102, 116
ferric chloride, 123
files, 123
firing brick, 24, 123
fleur-de-lis, 61, 65

hammering
 metal, 58, 122
 wire, 13
hammers, 124
hand drill, 124
headpins, 24
hearts, 34, 49, 53, 88, 90
heat gun, 124
hook clasp, 14

ink, 125
ivory, 66

jeweler's saw, 11, 124
jump rings
 with a drill, 12
 by hand, 11
 opening and closing,
 12

links, 13, 17
lockets, 43, 47

mandrels, 123
metal
 aging, 20
 etching, 22–23, 122,
 125
 hammering, 58, 122
 hole punching, 58, 122
 patinas, 20, 58
metal punch, 124
molds, 10, 124

necklaces
 Beauty's Desire, 56–59
 Charlotte's Wee Secret,
 78–81
 Faith, 60–63
 Fly Sweet One,
 118–121
 The Gift, 114–117
 His Wings, 106–109
 His Words, 64–69
 My Heart's Poem,
 86–89
 She Speaks of Truth,
 90–95
 Simplicity, 72–76
 View From Within,
 32–37

paper, 9, 10
patinas, 20, 58, 123
pearls
 stringing, 18–19
 types, 122
pin, 42–45
pliers, 124

resin
 adding color, 8
 backing bezels, 9
 bubbles in, 8
 drilling into, 9
 mixing, 8

object placement, 9
 pouring method, 74
 tape residue on, 88
resin clay, 88, 117, 120
resin paper, 10
reticules, 8
ribbon, 25, 87, 103, 125
rosary chain, 15
rubber stamps, 124–125

sanding tools, 125
sawing, 122
sheet metal, 125
silhouette images, 40, 44
silk shantung, 125
S-links, 13
soldering, 24, 59, 122
solvent ink, 125

two-part putty, 10, 123
two-part resin, 125

vintage paper, 9

wire
 gauges, 125
 shaping, 63
 turning a loop, 13
 twisting, 21
wire cutters, 123
wrapped dangle, 16
wrapped links, 17

More Charming Jewelry Instruction from North Light Books

A CHARMING EXCHANGE
By Kelly Snelling and Ruth Rae

Inside *A Charming Exchange* you'll find the works and words of more than 30 artists with an array of varying creative styles and insights on collaborative art. Learn how to create 25 jewelry projects using a wide variety of techniques, from working with basic jewelry findings, beads and wire to incorporating mixed-media elements such as solder, fabric and found objects into charms and other jewelry projects. The book even offers ideas, inspiration and resources for you to start your own online swaps and collaborations.

SRN: Z1653
ISBN 13: 978-1-60061-051-6

BEADED ALLURE
By Kelly Wiese

Discover the romantic aesthetic of beading with *Beaded Allure*.

You'll learn 10 beading techniques and stitches, complete with a step-by-step guide for 25 delicate and feminine projects. Learn a variety of stitches including brick, herringbone, peyote, picot, chain and more.

Author Kelly Wiese also shows you how to execute and combine these stitches into projects, some featured as jewelry sets. Whether you're a new or experienced beader or beadweaver, you will be enticed and excited by all this book has to offer.

SRN: Z4956
ISBN 13: 978-1-60061-768-3

STEAMPUNK EMPORIUM
By Jema Hewitt

In *Steampunk Emporium*, you are introduced to the rich charm and harrowing adventures of the steampunk world. Follow along with author Jema "Miss Emilly Ladybird" Hewitt as she takes you on a jaunt through 20 projects divided between five themed chapters, each its own fantastical story, and a host of jewelry, polymer clay and mixed-media techniques. Projects range from decadent jewelry, medals of great distinction, wine charms for imbibers, and many devices of note, all featuring authentic steampunk style and whimsy.

SRN: Z8074
ISBN 13: 978-1-4403-0838-3